MW00606352

IMAGES
of America

EVANSVILLE

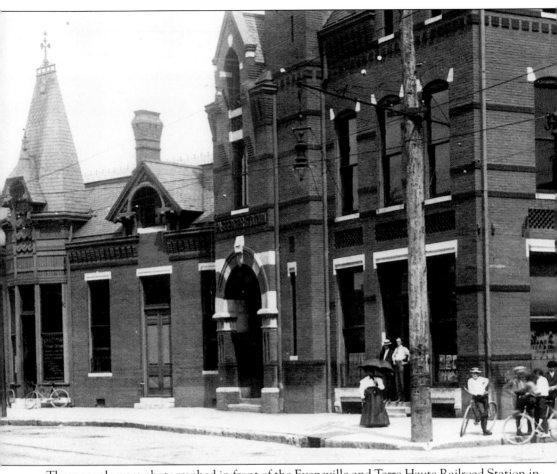

These people were photographed in front of the Evansville and Terre Haute Railroad Station in 1901. Located at Eighth and Main Streets, the building, erected in the early 1880s, was replaced by a structure in 1905 that was used until a union station was created on Fulton Avenue before World War II. During WW II the former station was used as the whites-only USO, and after the war it was used as a youth center. The Evansville and Terre Haute was Evansville's first rail line, connecting the city with Terre Haute in 1854.

IMAGES
of America

EVANSVILLE

Darrel Bigham

A Joint Project of
WFIE/NBC Channel 14 and Historic Southern Indiana,
a Heritage-Based Community Outreach Program
of the University of Southern Indiana

ARCADIA
PUBLISHING

Copyright © 1998 by Darrel Bigham
ISBN 978-0-7385-3923-2

Published by Arcadia Publishing
Charleston, South Carolina

Printed in the United States of America

Library of Congress Catalog Card Number: 2005931386

For all general information contact Arcadia Publishing at:
Telephone 843-853-2070
Fax 843-853-0044
E-mail sales@arcadiapublishing.com
For customer service and orders:
Toll-Free 1-888-313-2665

Visit us on the Internet at www.arcadiapublishing.com

A Joint Project of WFIE/NBC Channel 14 and Historic Southern Indiana, a Heritage-Based
Community Outreach Program of the University of Southern Indiana

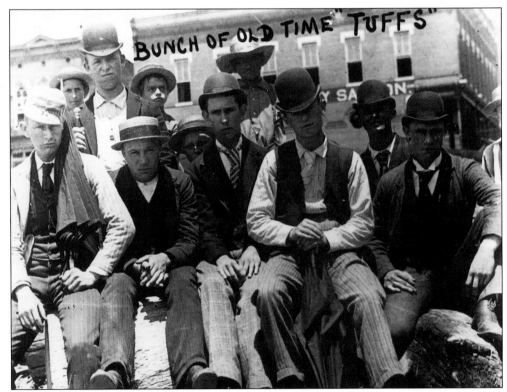

"Old time tuffs"—a group of youthful and perhaps would-be rowdies—were photographed at
the riverfront in Mount Vernon in 1898. Groups of boys like this could be found in the other
towns and cities of the lower Ohio as well.

CONTENTS

ACKNOWLEDGMENTS

This book originated in discussions earlier this year with staff members of WFIE, Channel 14, the NBC affiliate in Evansville which is celebrating its 45th year of service. Thinking about ways the station could suitably prepare programming for the new millennium, we agreed that as a historian with a long-standing interest in the Evansville region, I could help that process along by preparing an overview of the city and its region as it prepared for this last turn of the century. This work could in turn lay the basis for several years of programs on Channel 14 about how citizens could assess where their community was and what they hoped it would become—a "journey of change" for the people of the Tri-State. Without explicitly discussing historians' chief concerns—change and continuity over time—I could help initiate public discussion of these issues by attempting to portray the people and their institutions and organizations a century ago. Implicitly that would encourage viewers to ask what has changed—or not changed—and how and why this has occurred.

Project 2000 is a corporate-wide initiative of WFIE's parent body. The local committee's chair is Bob Freeman, news director. Steve Langford, vice president and general manager, has offered strong support. Allen Tumey and Don Moffett of the WFIE staff have been most helpful in developing this book. Don offered a great deal of advice on layout, located photographs, and arranged reproduction of some delightful illustrations at the midnight hour. All royalties from the sale of this book will be divided equally between the scholarship program of WFIE and the outreach projects of Historic Southern Indiana.

Most of the photographs used in this work came from the Special Collections Department of the David L. Rice Library at the University of Southern Indiana. As always, Gina Walker was cooperative, patient, and encouraging. Unless otherwise noted, the photos are in the University of Southern Indiana collections. Willard Library's staff was also most helpful. Their contributions to this book, as well as those of a few individuals in Henderson and Owensboro, are duly noted.

I would like to offer this volume as a modest expression of appreciation to the memory of Alexander L. Leich, a longtime resident of Evansville who was one of the city's earliest and most devoted champions of historic preservation, and who strongly encouraged and assisted my research.

INTRODUCTION

As we approach 2000—symbolically but not quite actually the dawn of a new millennium as well as a new century—we are irresistibly drawn to thoughts about the future. We are also invariably led to consider whence we have come. This little volume focuses on Evansville and its hinterlands or service area, known since the 1870s as the Tri-State, during the transition from the 19th to the 20th century. Most of the photographs are about a century old—roughly 1898 to 1900, when our forebears were thinking similar thoughts about destinies and origins. The remainder stretch from 1889 to 1911.

The Evansville of a century ago was vastly different from its late-20th-century descendant. It was the "radial center" of a vast service area stretching from 75 to 125 miles in all directions. Its manufacturers, commerce, transportation, and other services accounted for its rapid growth and development since the 1840s and shaped the lives of thousands of people in western Kentucky, southeastern Illinois, and southwestern Indiana. Through the Ohio and its tributaries (the Green, the Wabash, the Cumberland, and the Tennessee), as well as the numerous railroads linking the city to the region, Evansville products like plows, stoves, cigars, flour, and furniture, were well known throughout the lower Midwest and the upper South. Rail links to the growing national urban market, moreover, brought Evansville brand-name goods, like Swans-Down Cake Flour and Charles Denby cigars, to consumers hundreds of miles away.

One hundred years ago, Evansville and the Tri-State were in the midst of a vast social, economic, and political transformation. Agriculture was becoming mechanized, scientific farming was introduced, and agricultural products were linked to national and international markets. Industry was not only creating huge and vastly different types of cities and developing new and, to many, bewildering forms of corporate organization, but also laying the basis for a consumer revolution.

Evansville, a city of about 60,000, was by far the largest city between the falls of the Ohio and the mouth of the river, 325 miles away. The next largest city, Paducah, had about 19,000 residents, Owensboro about 15,000, Henderson nearly 10,000, and Mount Vernon 5,000. Size alone did not account for differences between Evansville and its neighbors. It was on the verge of becoming a metropolis, a federal census bureau designation for a region with a large urban core and a substantial urbanized region of influence. Unlike its urban neighbors on the lower Ohio, moreover, its economy was not dependent on one or two products, but was relatively diverse. In this era, the most important manufactured products were furniture, plows, stoves, other foundry goods, cigars, and flour. Its population was also distinctive. Though heavily

shaped by migrants from the upper South, it had a huge (approximately 40 percent) number of first- and second-generation German Americans. And about 13 percent of Evansville's residents in 1900 were African American, the largest percentage in Indiana and one of the largest in the Midwest. Numerically, most of the population was Indiana born.

In the late 1890s—gay and innocent, optimistic and naive on the surface—another sort of transformation was occurring. Evansville's workers were increasingly likely to be employed by a corporation and work in a large factory managed by agents for distant owners. Not surprisingly, unionization was a growing fact of life. The rapid growth of the black community, in an era in which Jim Crow (legalized segregation) and racial violence were increasingly evident across the South and southern Midwest, brought racial tensions that would explode in a few years in an unprecedented race riot in July 1903. Women's literary, social, and benevolent organizations—the result of the extension of proscribed women's roles into the public arena—were laying the basis for extensive political activity culminating in the achievement of the vote. Politically, concerns about voting corruption—a longtime feature of Evansville elections—produced a series of reforms, such as the secret ballot. The miseries produced by the corporation and the large city also were preparing Evansville, and the nation, for the age of progressive reform, presided over by presidents Theodore Roosevelt, William Howard Taft, and Woodrow Wilson. And in 1898, a short war with a third-rate power over Cuban nationalism led to the entrance of America into the age of imperialism and world war.

Finally, our forebears a century ago did not have air conditioning (and most did not even have electric lights), thus forcing us to reflect on how anything got done between May and October. They did not have paved roads, automobiles, or airplanes. Most never ventured outside their city or off their farm. If they traveled, the distance was relatively short. Even if they could travel farther, the "pocket" of Indiana provided a distinctive challenge. There was only one river bridge, and between November and June the depth of area rivers isolated most area residents. Communication was mostly by word of mouth, although telegraphs, telephones, the nickelodeon, and inexpensive newspapers and magazines were beginning to enrich traditional sources of information. Radio was years away, and television—let alone the internet—had not even been imagined. To most, the federal government was the post office. City government offered relatively few services and was hobbled by a myriad of state government restrictions. Schooling went, at most, to age 13. Employers provided no health or disability benefits, no vacations, and no overtime pay, and on the average, workers put in 60 hours in five and one-half days a week, earning about $380 a year. Social Security and the minimum wage were about four decades distant. Life expectancy was about half of what it is now. Tuberculosis and other diseases associated with city life ravaged the community.

A century ago, in short, residents of Evansville and the Tri-State lived in a world that in many respects was more similar to that of their grandparents and great-grandparents than to that of their descendants a century later. One should temper nostalgia for that simpler, seemingly more optimistic time with the reminder that the past looks good because it is not here.

One

THE URBANSCAPE OF AN INDUSTRIALIZING CITY

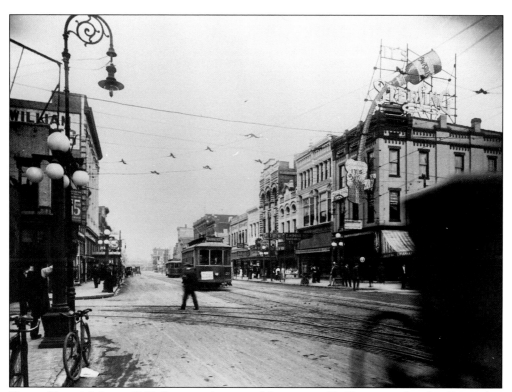

Pictured here is Main at Fifth Street at the turn of the century. Trolleys, introduced in September 1892, are in evidence, as are bicycles and carriages. Automobiles are not present. The impact of electricity, introduced here in the early 1880s, is illustrated in street lights and the Sterling Beer advertisement.

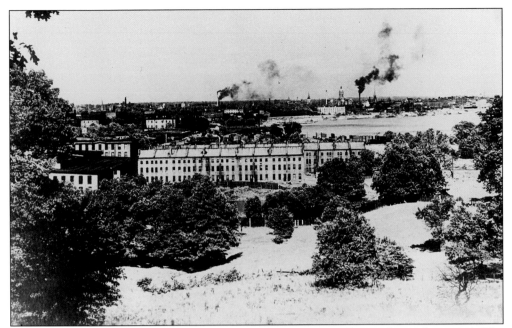

This is the view looking east from Coal Mine Hill to the Evansville riverfront, about 1910. The skyline is dominated by smokestacks and the recently completed courthouse. In the foreground is the Evansville Cotton Mill, which ceased operations about 1910. In 1915 the facility was purchased by Mead Johnson and Company.

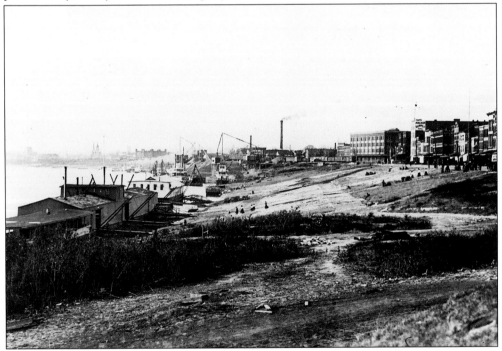

The Evansville waterfront is seen here, looking to the west, about 1900. Improvements such as grading and the addition of cobblestones are evident. Several wharf boats are tied up at the water's edge. In the distance is the industrialized west side, formerly Lamasco.

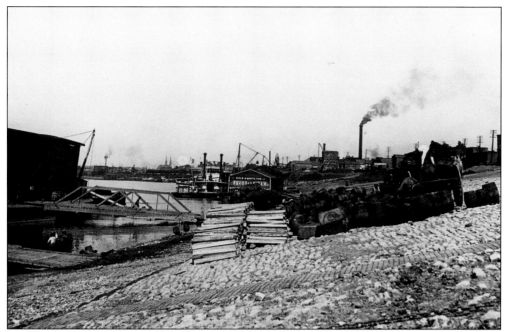

This picture was taken at the Evansville riverfront, looking west. Stacks of barrels and lumber were commonplace. The city began grading and adding cobblestones to the slope below Water Street in the late 1840s. This site was modernized with a cement pavement and esplanade in 1936.

This view from the riverfront looks up to Water, Sycamore, and Locust Streets. This low water (summer) shot was taken in 1899.

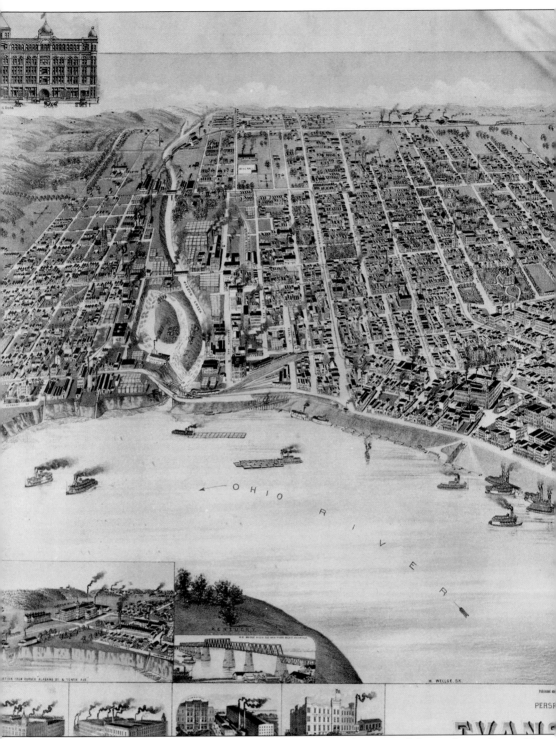

"Bird's-eye views" were popular between 1860 and 1918. Advances in lithography made possible inexpensive copies that signified urban affluence and pride. They also offered a portrait of urban harmony—for example, picturing factory smoke as a sign of progress. This one of Evansville was

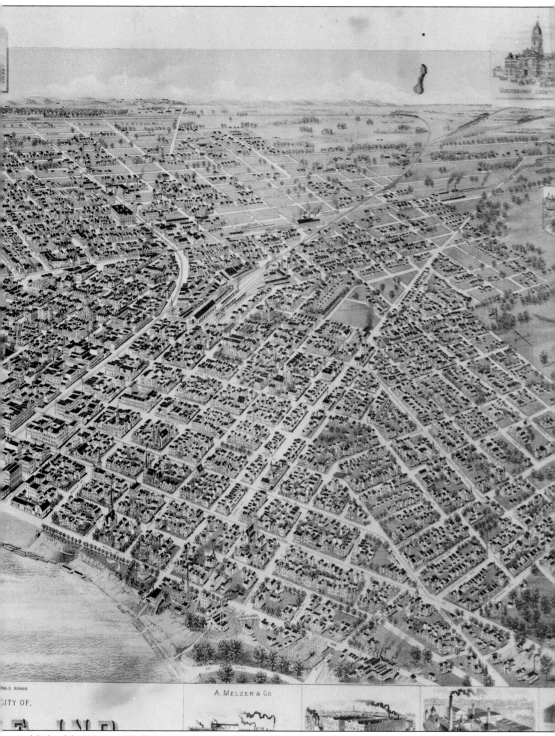

VANDERBURGH COUNTY

A. MELZER & Co

ITY OF.

published by Henry Wellg's American Publicity Company of Milwaukee in 1888. Aerial views of two other lower Ohio cities, Cairo and Paducah, appeared about the same time.

13

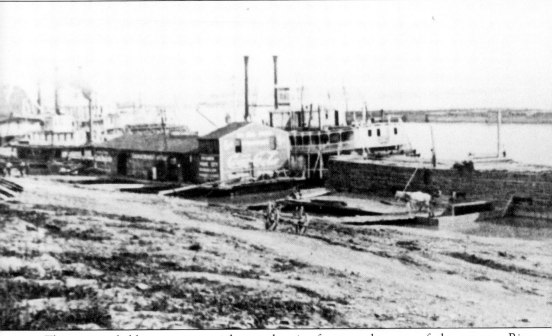

This was probably a common sight on the riverfront at the turn of the century. River commerce, despite the coming of railroads 50 years earlier, continued to play an essential role in

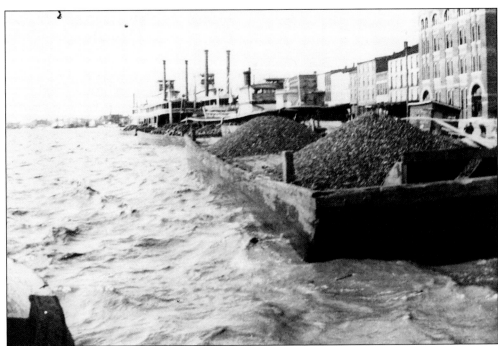

Photographed during high and choppy river water is a coal barge tied up at the riverfront. Unidentified steamers are in the background. The use of coal for river craft, locomotives, factories, and residences, was uncommon before the 1850s. Evansville's mines became a major supplier for the region, although much coal was imported from up-river mines.

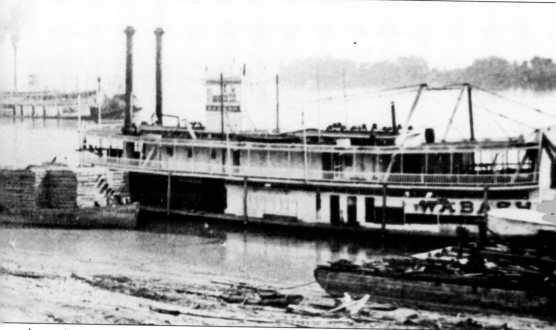

the city's economy.

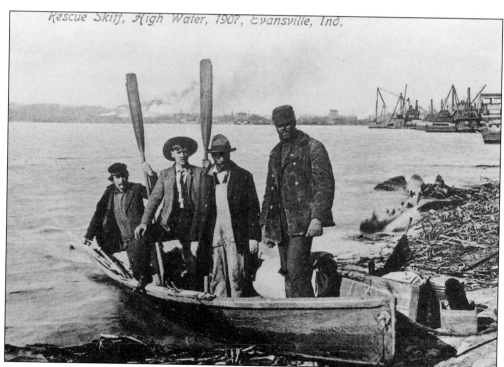

Rescue Skiff, High Water, 1907, Evansville, Ind.

A postcard, made after the 1907 flood, honored the crew of a rescue skiff. Racially mixed work forces in those days were rare in this segregated city. Civic emergencies, though, sometimes transcended these practices.

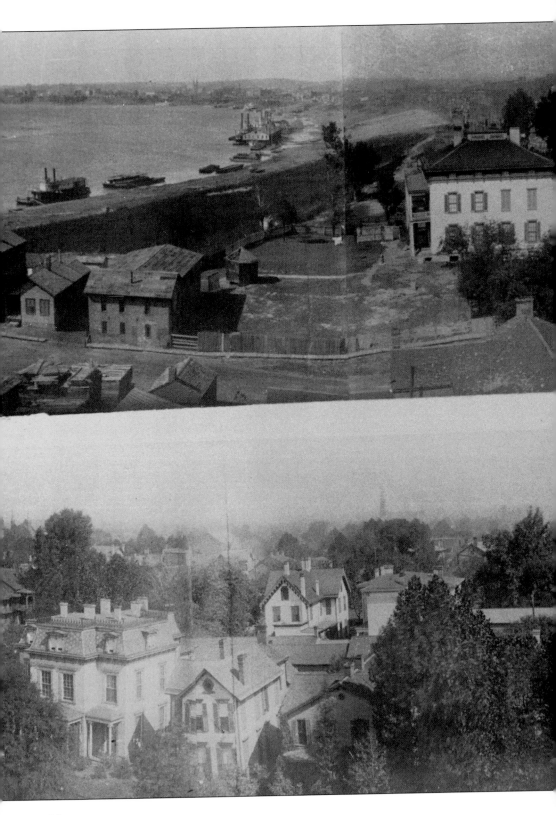

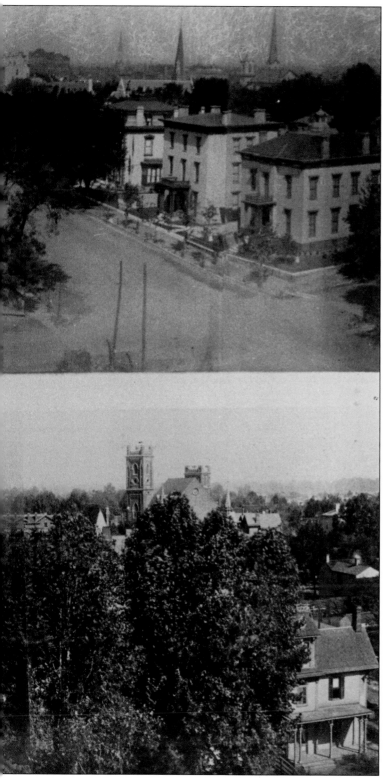

Taken from the tower of the old waterworks, these photos reveal, at the top (left to right), the city's levee and waterfront. Some marginal housing remains, but the region is becoming the center for affluent English-speaking residents. The Armstrong mansion (razed in 1910) is across the street from the grand, late-Victorian homes on Upper Water. At the bottom are additional homes along Upper Water—some much grander than others. The Walnut Street Presbyterian Church is in the right background.

17

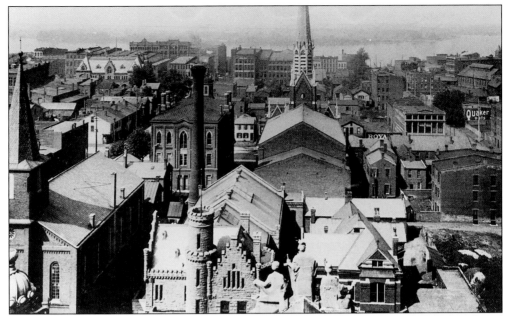

This view was from the courthouse to the river, about 1901. Holy Trinity Catholic Church and its school are beyond the jail (foreground). This German parish, the city's first, was organized by John A. Reitz in the late 1840s. To the left of the jail is the Fourth Street German Methodist Episcopal Church.

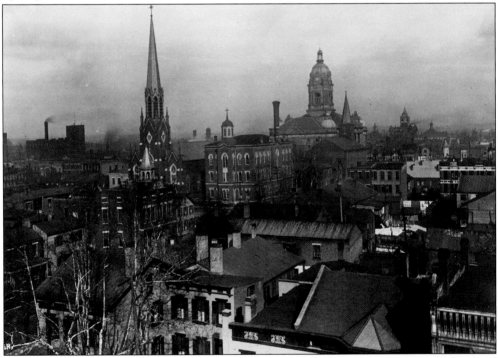

Taken from the post office in 1907, this photograph captured the opposite perspective, back toward the courthouse. Second Street is in the foreground. Vine Street is to the left. Trinity Church and School are in the background. In the distance is the Evansville High School tower.

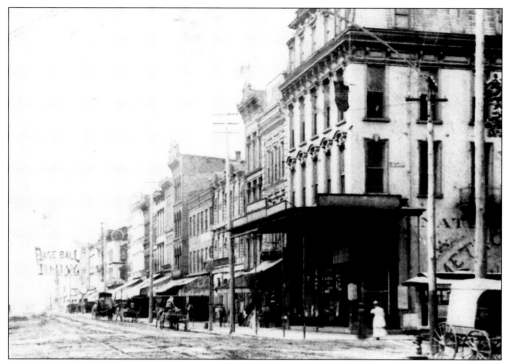

This is a summertime scene, about 1903, at Third and Main Streets. To the right is the Washington Hotel (1855), which by tradition offered shelter for fugitive slaves in its basement. The building—covered with a 1960s facade—still stands. The city's baseball team was playing the day this was taken.

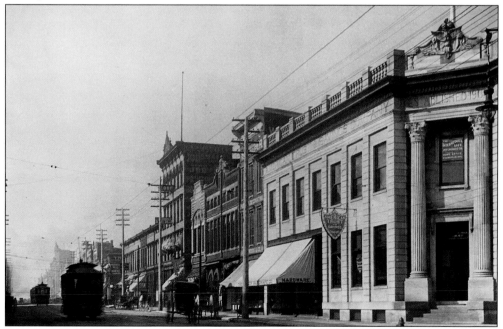

American Trust and Savings Company, at Sixth and Main, was organized a few years before this scene in 1906. Trolleys and horse-drawn vehicles are much in evidence.

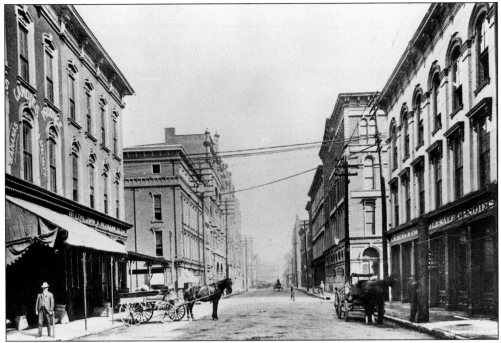

This was Upper First, near Sycamore, in 1901—a glimpse of downtown commercial architecture. Included are John G. Neumann Company at number 201 (left)—commission merchants of produce, fruit, seed, feed, and hay—and A.W. Henn and Company at numbers 200–202 (right)—wholesale candy manufacturers and confectioners.

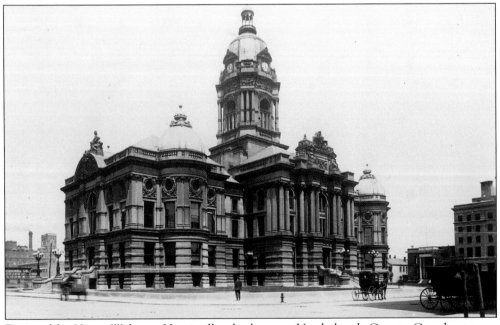

Designed by Henry Wolters of Louisville, the baroque Vanderburgh County Courthouse was opened in 1891—a testament to local prosperity and the presence of a skilled work force. The picture of Evansville's third courthouse was taken c. 1900.

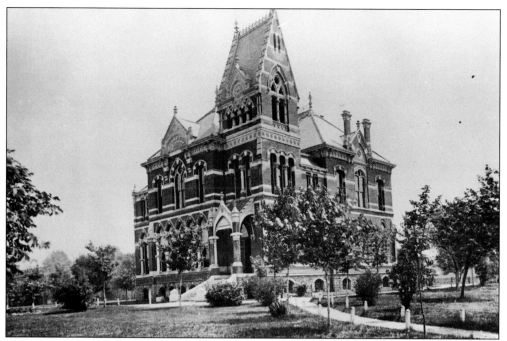

Willard Library and Park are shown about 1900. The public library, a gift of entrepreneur and philanthropist Willard Carpenter, was opened in 1885, shortly before his death. Carpenter, a Vermonter by birth, came to make his fortune in the then small town in the mid-1830s.

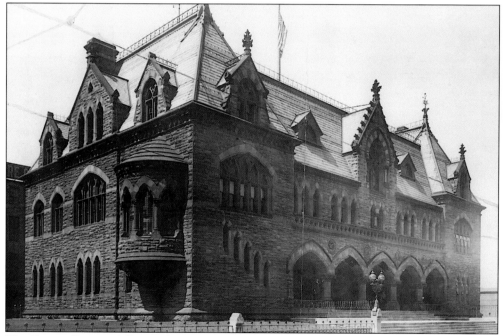

The Evansville Post Office and Customs House, on Second near Vine, was the city's grandest public building when it opened in the late 1870s. The magnificent Romanesque structure in the style of H.H. Richardson remains one of the most striking features of the downtown. (Courtesy of Willard Library.)

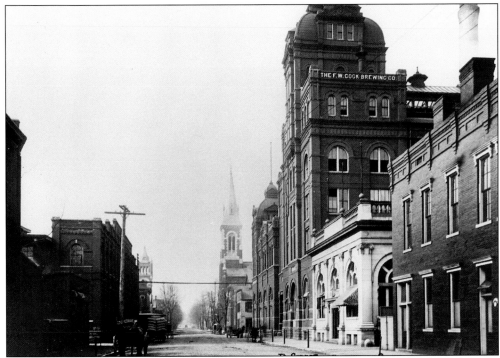

This is Seventh Street, looking north from Main. F.W. Cook's Brewery, including the new (1893) brewhouse, is on the right. In the distance are Evansville High School (left) and Assumption Cathedral (right).

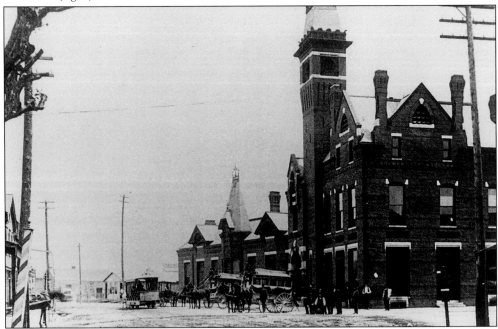

The Evansville and Terre Haute Railroad Station on Eighth, near Main, was photographed in the early 1890s. Horse-cars connected the station to river transport as well as other portions of the city. Electric trolley service was introduced on September 15, 1892.

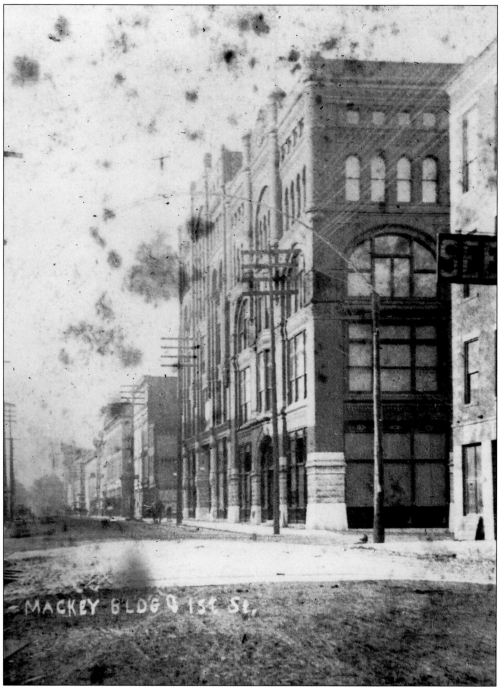

This was the Mackey Building, at 101–105 First Street, built in 1897. Later it was known as the Mackey-Nisbet Building, where wholesale dry goods were sold. David Mackey (1833–1914) was the most storied of Evansville's self-made men, making a fortune in wholesale commerce and then banking, coal, and railroads. In the 1880s he dominated most area lines. First president of the Evansville Business Men's Association, he also built the grand St. George Hotel. He lost it all in the Panic of 1893, and died in modest circumstances.

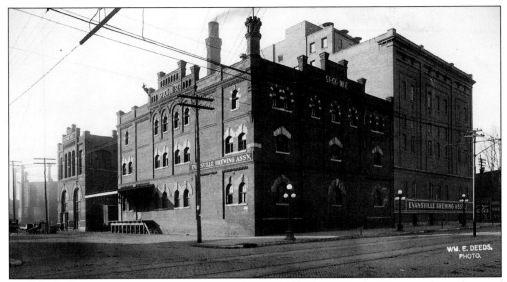

These are the buildings of the newly formed Evansville Brewing Association, formed out of three firms in the early 1890s. The alliance built the new brewhouse in the foreground. The company and its descendants, located at Fulton and Pennsylvania, survived until early 1998.

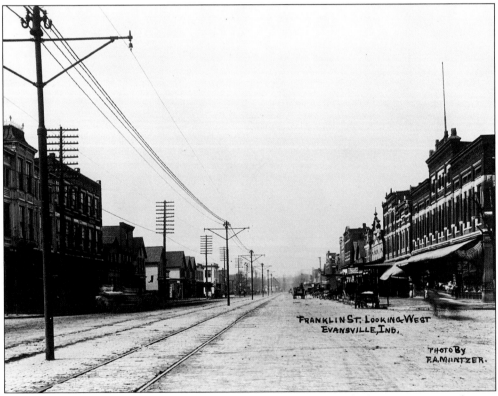

This photograph of West Franklin Street, looking west from Wabash Avenue, was taken in 1909. This street was the main commercial corridor of Independence, a German-American community annexed by the city in the late 1860s.

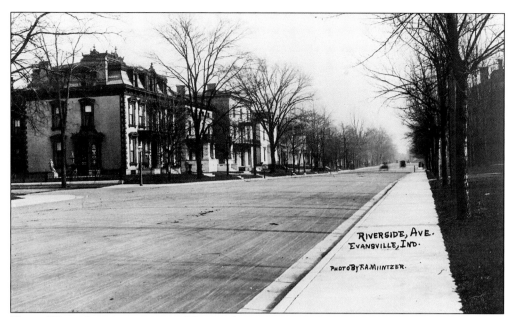

Upper Water Street was renamed Riverside at the turn of the century to enhance its image. The jewel of the city's wealthiest residential district, where English-speaking merchants and bankers predominated, was the Charles Viele home (left). Across Water (right) was the Barnes-Uel-Armstrong mansion (1850), the city's first museum (1904–1910).

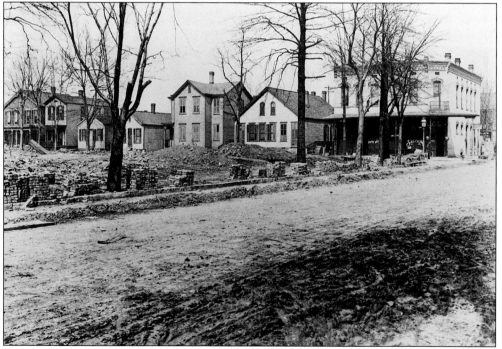

Evansville's near-downtown neighborhoods at the turn of the century contained varied housing stock, and services like groceries and saloons were widespread. This Evansville neighborhood, at Seventh and Court Streets, was in the process of gaining bricked streets and contained several modest "shot-gun" houses.

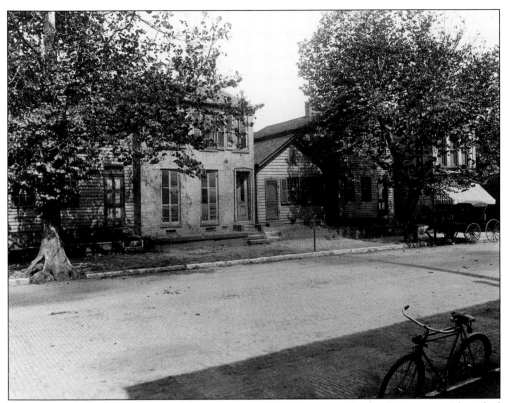

This row of fairly modest mid-19th-century residences was located in an unidentified neighborhood near downtown. Workers there were employed mostly in downtown commercial establishments, transportation, and public service—hotels and restaurants for example.

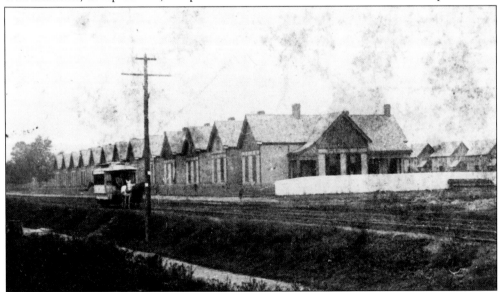

The William Heilman Block provided workers' homes on West Maryland Street in the early 1890s. A barn for horses that pulled the omnibuses was nearby at Fulton and Grove. Most workers on the west side were employed in woodworking factories or foundries.

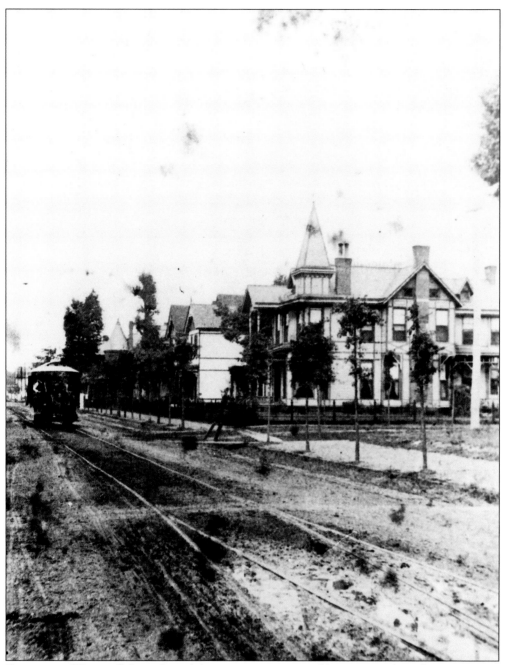

Expansion of Evansville's residential districts was encouraged by street car lines, begun in 1867. Electric-powered trolleys began to replace horse- and mule-powered cars in 1892. This was a view of affluent Washington Avenue, just east of downtown, in the early 1890s.

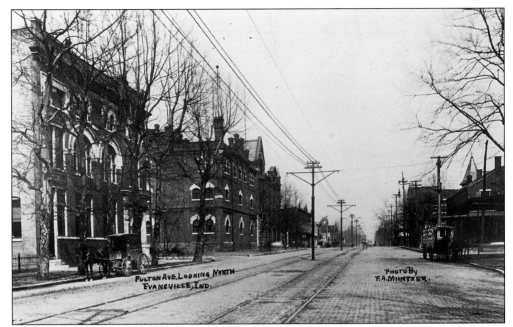

This was Fulton Avenue, looking north from Pennsylvania, about 1900. Trolley service had been recently installed. The most important north-south corridor on the west side, Fulton boasted some of the city's leading German-owned businesses and industries. Families of all social ranks resided on it.

The city's near north side boasted many impressive middle-class homes. This was the residence of photographer Thomas Mueller at 103 East Columbia Street, near Elsas, shortly after its completion. The home still stands and is in very good condition.

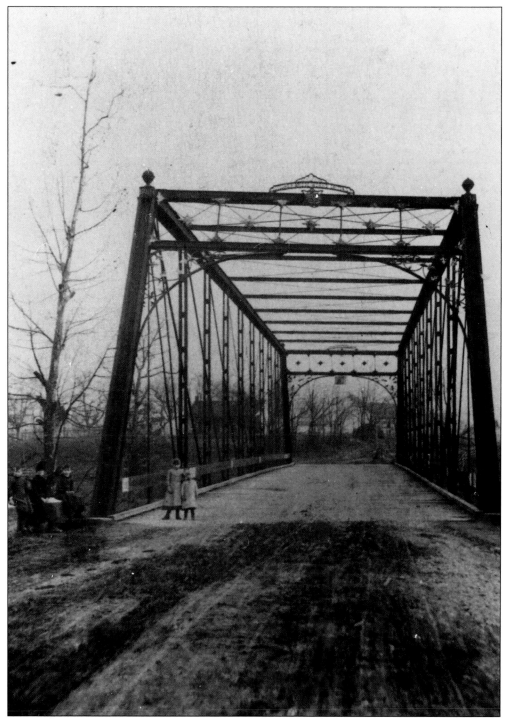

The bridge over Pigeon Creek on Stringtown Road is shown here shortly after its completion. Since bridges within city limits were rare, isolation encouraged strong neighborhood identities. Even rarer were bridges connecting the city to the larger world. There was only one at the time—the L and N Railroad span over the Ohio.

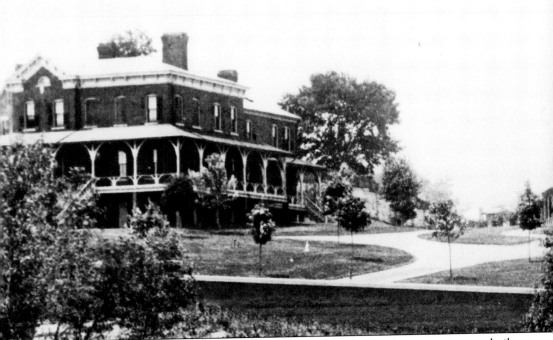

The United States Marine Hospital, a federally supported facility for river-men, was built on West Indiana Street, near Barker, in the 1880s. The first Marine Hospital was opened in the

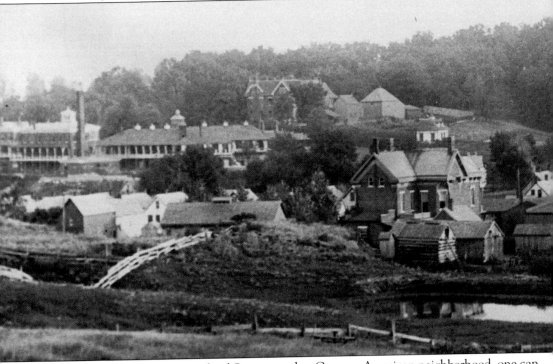

From the summit of West Maryland Street, another German-American neighborhood, one can see tobacco-drying sheds to the south and beyond them (upper left, on West Indiana Street,

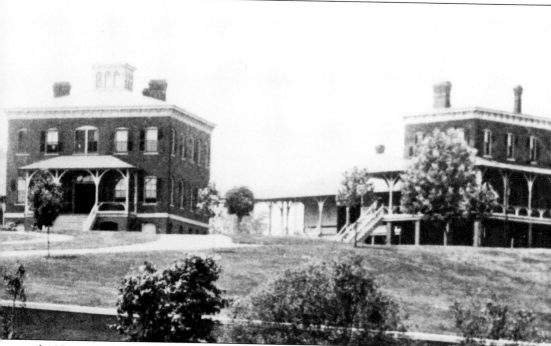

mid-1850s, a block from the Ohio.

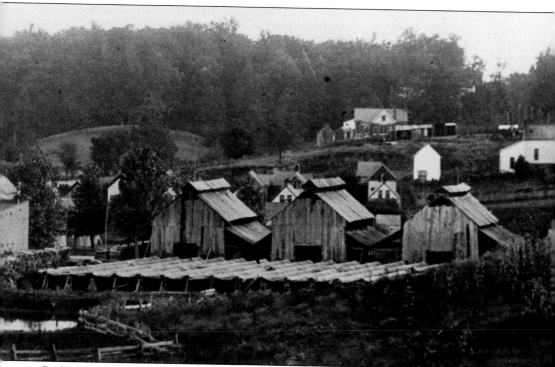

near Barker Avenue) the buildings of the second Marine Hospital.

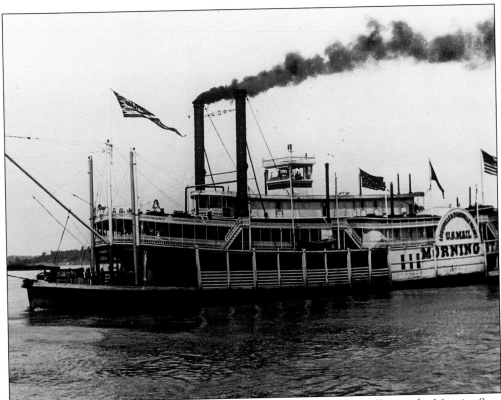

A familiar landmark on the riverfronts between Evansville and Louisville was the *Morning Star*, a mainstay of the Louisville and Evansville Packet Line.

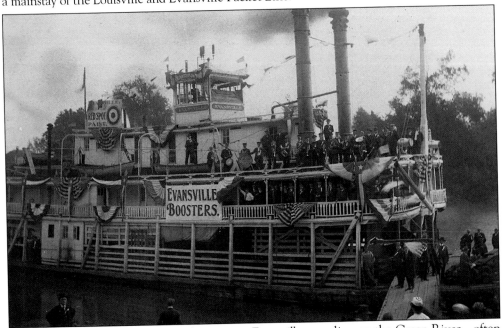

Evansville boosters—this time on the steamer *Evansville*, traveling on the Green River—often scoured the Tri-State to promote Evansville businesses and manufacturers.

Two

MAKING A LIVING

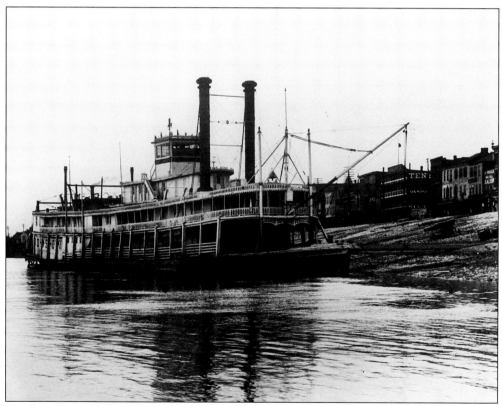

The *John Stuart Hopkins*, named after one of the city's leaders, signified the continuing vitality of river trade. Built in Pittsburgh in 1880, it was a mainstay of the Evansville, Paducah, and Cairo line. The 200-foot-long craft became an excursion boat in 1912 and was destroyed by fire in 1917.

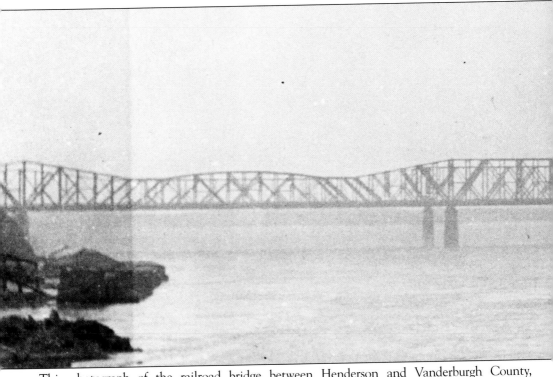

This photograph of the railroad bridge between Henderson and Vanderburgh County, photographed around 1910, captured a train which had just crossed the river (right). Completed in 1885, the bridge was part of the rapidly expanding L and N's plans to consolidate and

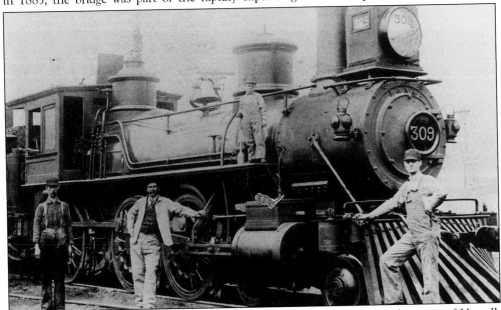

This was L and N engine 309, with crew, at the Howell yards c. 1910. The town of Howell, located on the city's southwest side, was incorporated in 1889, shortly after the opening of the railroad bridge and the L and N freight yards. It was annexed in 1916. Most of its residents were from Kentucky or Tennessee.

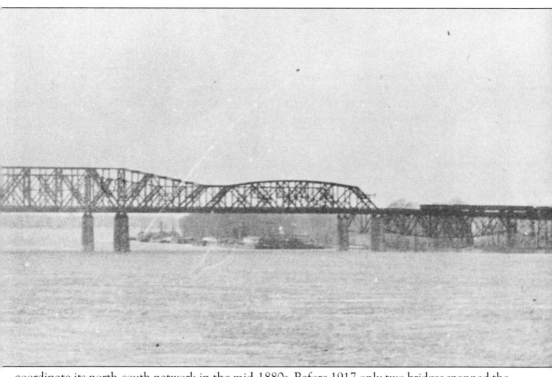

coordinate its north-south network in the mid-1880s. Before 1917 only two bridges spanned the Ohio downriver from the falls of the Ohio. The other bridge was at Cairo, Illinois.

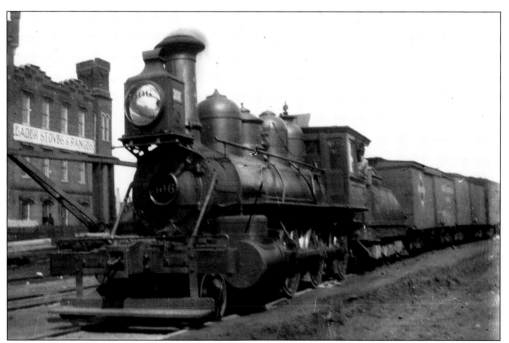

Engine 306 of the L and N was photographed as it rolled past the Kiechele-Brentano-Oberdorfer Foundry, later the Southern Stove Works, at Seventh Avenue and Ohio Street

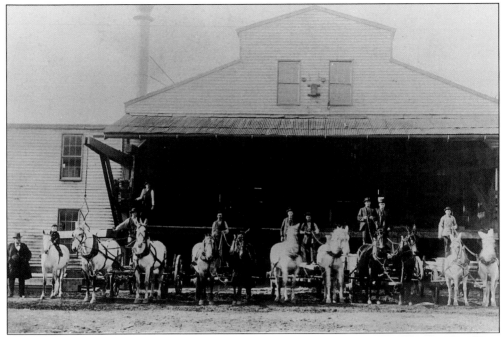

These were employees of the Clemens Reitz Sawmill, about 1900, with wagons and horses. Between the Civil War and the 1930s, wood products consistently ranked first or second in value among Evansville industries.

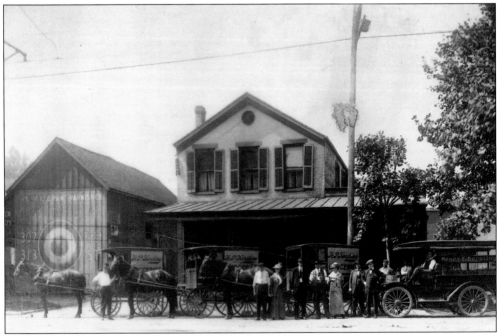

Delivery wagons of Henry F. Kersting's grocery at 121 West Franklin Street were juxtaposed with the firm's new delivery trucks. Trucks greatly expanded the service range of urban businesses and thus the reach of emerging metropolises like Evansville.

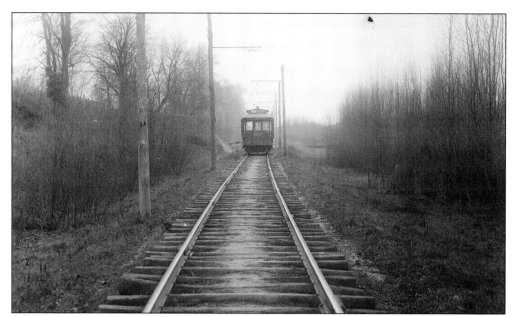

This was a traction car on the electrified interurban line linking Evansville with Princeton and Hazleton to the north. This car was photographed somewhere in Gibson County. One of the consequences of this line was the expansion of the number of Evansville workers living outside Vanderburgh County. (Courtesy of Willard Library.)

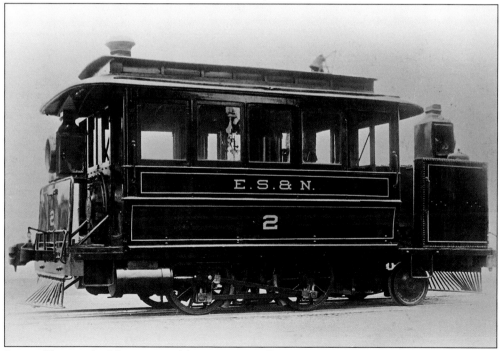

Pictured here is the "dummy car" (disguising a small steam engine) of the Evansville, Suburban, and Newburgh Railroad. Organized in 1889, it was the first of several interurbans in southwest Indiana. The line, from its station near Fifth and Main, provided passenger service to Boonville and Newburgh. It also carried coal and freight.

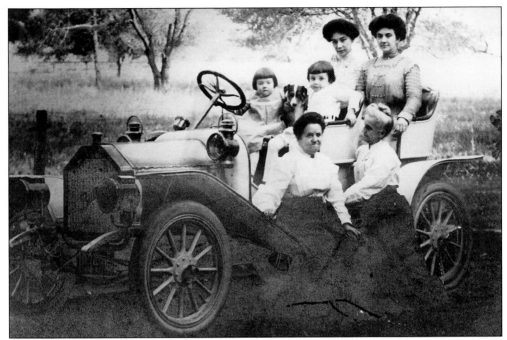

Automobiles were, at the turn of the century, an attractive though expensive and rare means of transport. These Evansville girls and women (including Florence and Isabel Dannettell, seated on the back seat of this Buick, *c.* 1905) could not imagine the impact that the auto would have on their future lifestyles or their city.

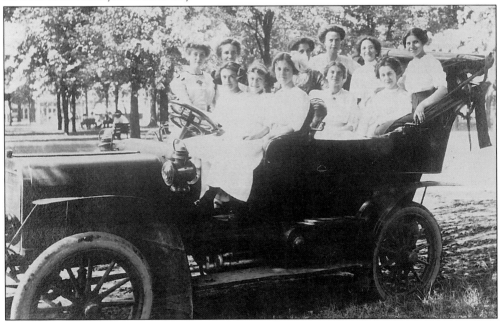

The Simplicity was manufactured in Evansville between 1907 and 1911. The only other locally produced brand was the Sears, sold via catalog. Willis Copeland made the Simplicity in the Singer Center Buggy Works, at Fifth and Locust Streets. This is probably the 1907 Model C, being promoted by a number of young women.

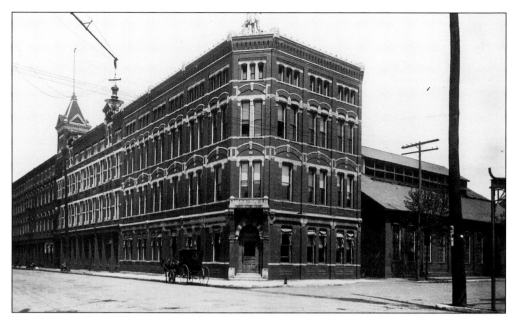

The Vulcan Plow Works was eventually moved to First Street, between Court and Ingle. Descendant of William Heilman's foundry, formed in the 1840s, this was one of Indiana's largest plow makers. The statue of Vulcan (now housed in the basement of the old courthouse) towered over the building. (Courtesy of Willard Library.)

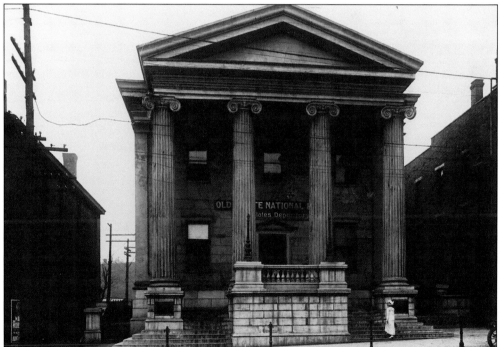

The Greek Revival Old National Bank (1837), at 10 Main Street, was abandoned just before WW I for a much larger structure near Fifth and Main. This was Evansville's branch of the Second State Bank system, formed in 1834. Old National Bank's long-since razed building has cousins which still stand in New Albany and Vincennes.

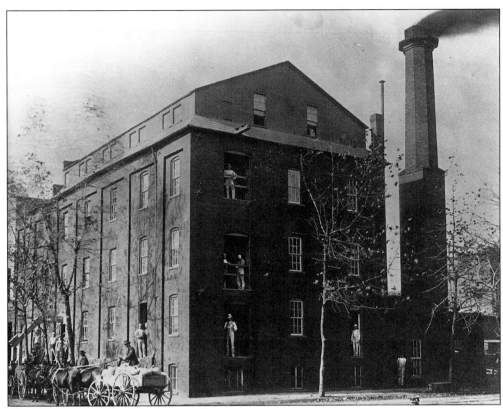

The Igleheart Brothers flour mill (1856) was located at present-day Fifth and Locust Streets, on the old Wabash and Erie Canal. It was relocated on the belt line railroad on the city's far north side in 1910. Beginning in the 1890s, Igleheart manufactured one of the region's first nationally-known, brand-name products—Swans Down Cake Flour.

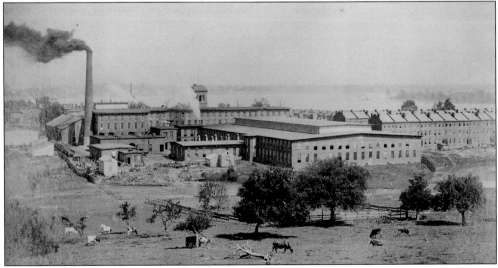

This was the Evansville Cotton Mill, about 1890. The company, organized shortly after the end of the Civil War, was the lower Ohio's leading employer for many years. Many workers were women and children. Tenements for workers are seen on the far right.

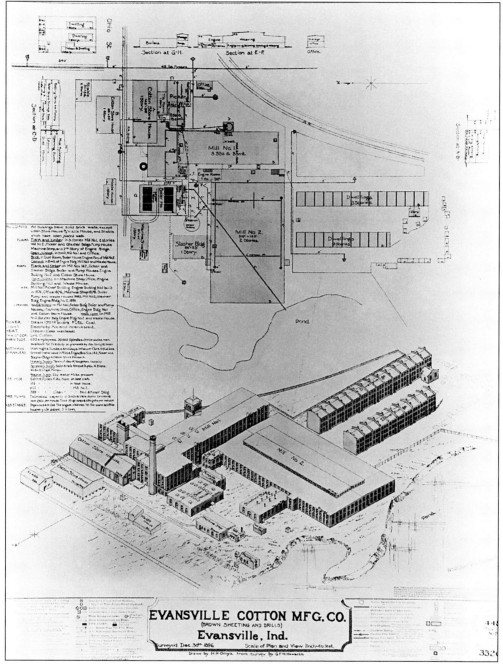

This was the site plan of the Evansville Cotton Mill, December 30, 1896. The photograph to the left was taken from approximately the same perspective. At this time the company employed six hundred and had almost 40,000 spindles.

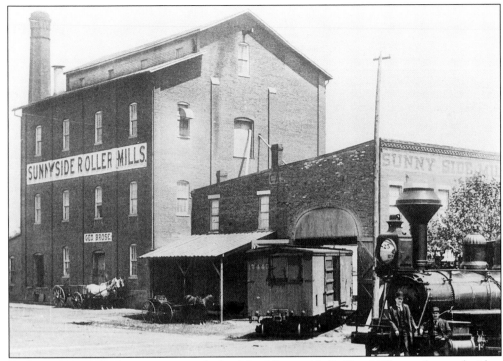

Rail service was clearly important to the health of Sunnyside Rolling Mills, on the north side.

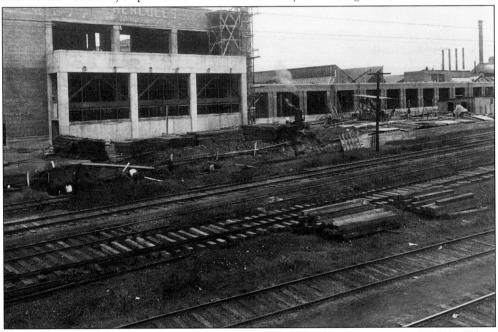

The Hercules Buggy Factory was photographed while under construction (1902). When completed (1903), the 32,000-square-foot facility produced one buggy every five minutes. It was bounded by east Illinois, east Indiana, Morton, and the city limits. Owner William McCurdy later expanded into gasoline engines and truck bodies. In 1926, the facility was reorganized as Servel, manufacturer of gas-powered refrigerators.

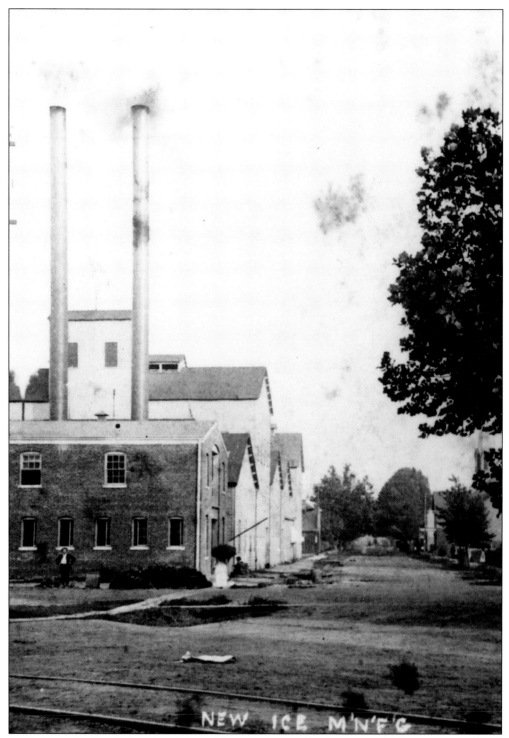

NEW ICE M'N'F'G

A vital cog in the city's industrial machine was ice production, essential for commercial and residential refrigeration. This is the new Ice Manufacturing Company of Evansville in the early 1890s.

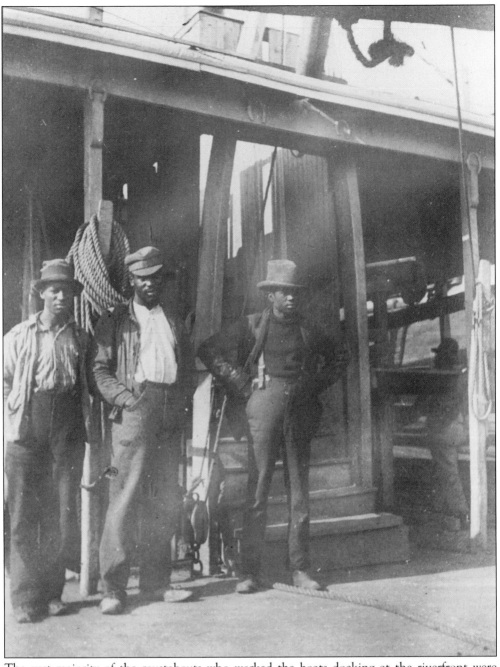

The vast majority of the roustabouts who worked the boats docking at the riverfront were African American.

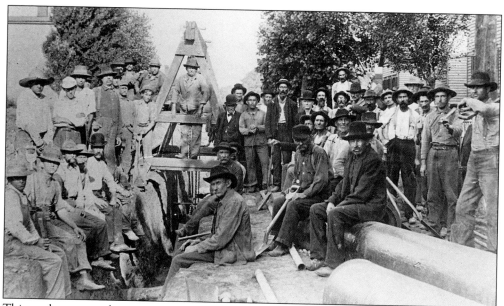

This work crew was laying sewer pipe on the near north side about 1905. Labor-intensive work of this sort was closely linked to the tides of local elections.

An unidentified group of workers is pictured here around 1900. Probably day laborers or construction hands, they were also mixed by race and ethnicity. A man in the front, for instance, wore a German army cap, and two in the rear were African Americans.

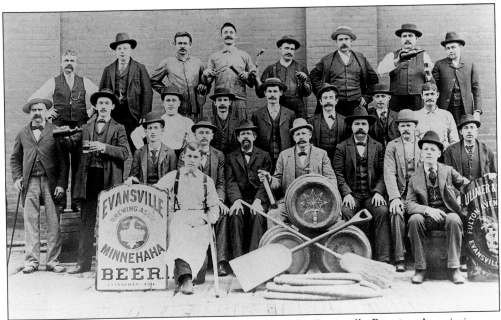

The diverse skills and camaraderie among workers of the Evansville Brewing Association are evident in this photo. The Evansville Brewing Association, formed in the early 1890s, comprised John Hartmetz and Son, the Evansville Brewery, and the Fulton Avenue Brewery. Several brand names are displayed.

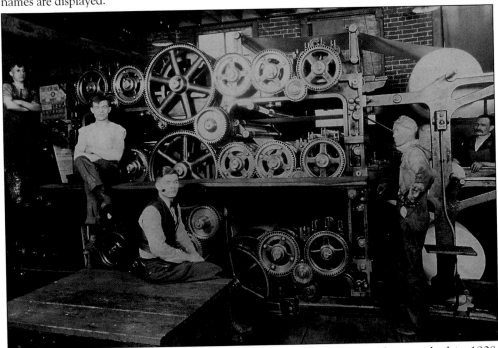

The first printing press in the first home of the *Evansville Press* was photographed in 1908. Pictured left to right are: Eugene Pfafflin, stereotyper; Arthur J. Becker, stereotyper; Karl Weber, circulation department; Fred Dabler; and John H. Litmer. The first issue of the *Press*, a Scripps paper, appeared on July 2, 1906.

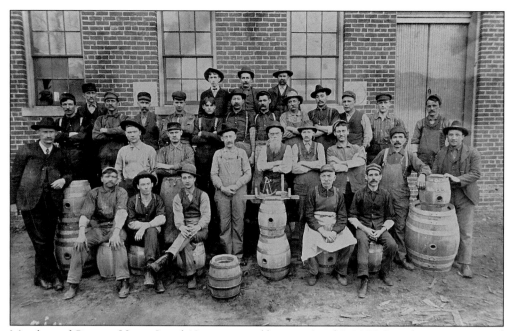

Members of Coopers Union Local 12 are pictured here on April 8, 1905. Barrels were an integral part of commerce and industry when most products were shipped by bulk on steamboats or rail cars.

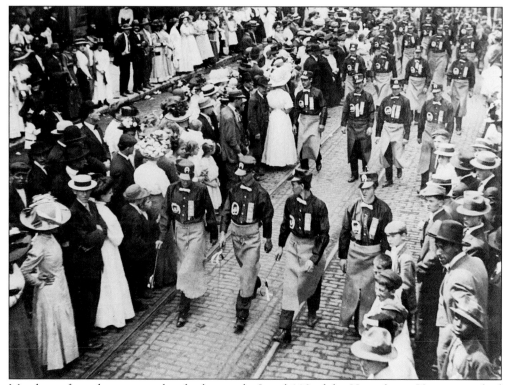

Members of another soon-to-be obsolete trade, Local 110 of the Horseshoers Union, marched in Labor Day festivities on September 2, 1909.

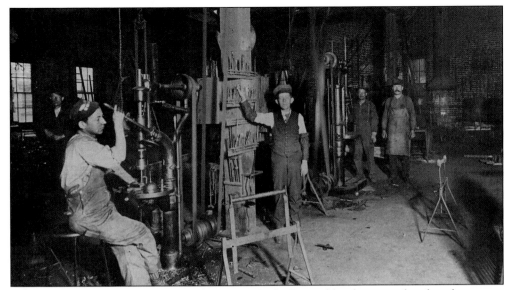

Workers at the Lindenschmidt Foundry, at 411 Ingle Street, like those at other foundries, were more skilled than most. This foundry made fire escapes and ornamental iron work. In 1900 the average Evansville wage earner received $379 annually, while foundry workers made $529. The youths in the foreground were probably apprentices.

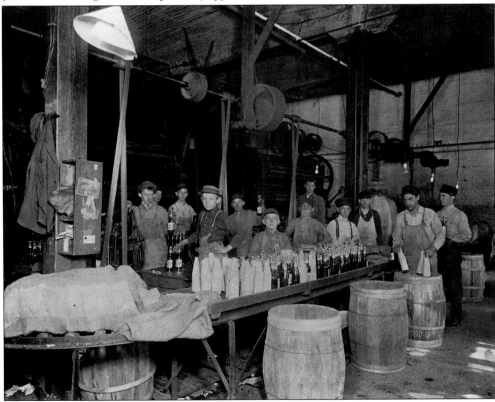

Boys prepared bottles of Sterling Beer for shipment. Indiana child labor legislation between 1890 and 1914 limited, but did not eliminate, the employment of youths under age 16.

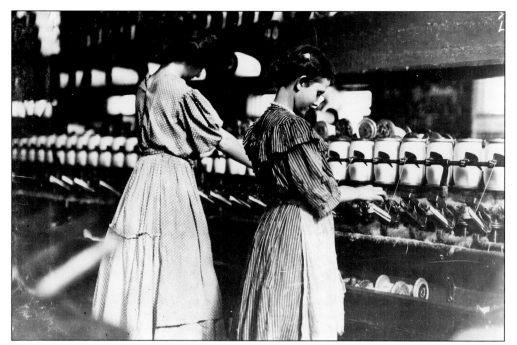

Photographer Lewis Hine toured the nation on several occasions to document industrial abuses for social reform agencies. In October 1908 he took this photograph in Evansville's Lincoln Cotton Mill. The girls are identified as spoolers. (Courtesy of Library of Congress.)

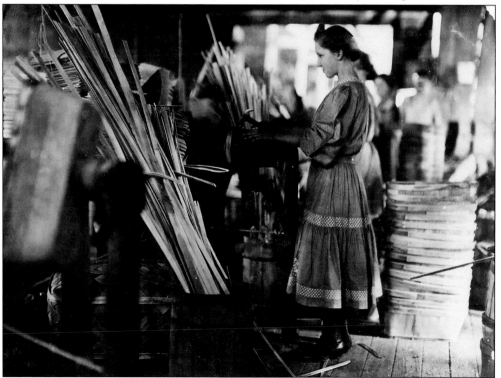

Hine identified this girl simply as a maker of melon baskets. (Courtesy of Library of Congress.)

This unidentified peddler sold inexpensively framed photographs from the back of his wagon. Gas lights are still in evidence in this view of Line Street about 1905. (Courtesy of Willard Library.)

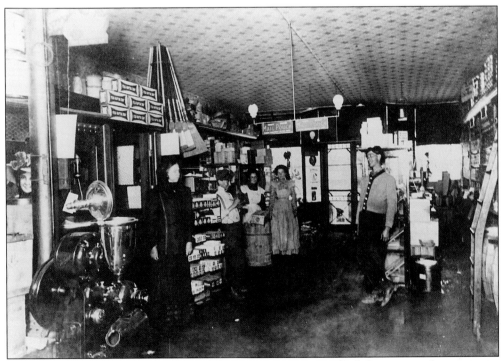

This was the interior of an unidentified grocery store—typical of the scores of groceries in Evansville and its environs.

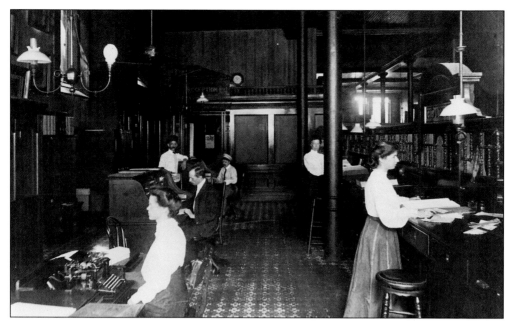

White-collar workers were increasingly commonplace in the age of industrial urbanization. A growing number of office workers, moreover, were women—in this case, at the Evansville Gas Company, a predecessor of Southern Indiana Gas and Electric.

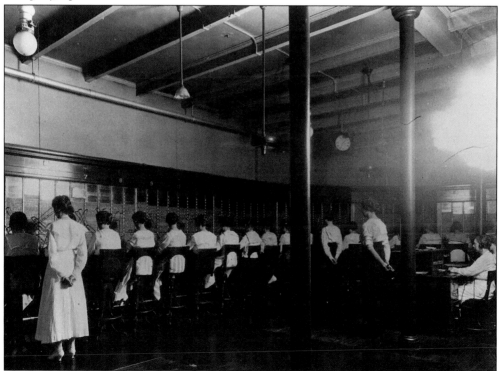

These are telephone operators and their supervisors at the Cumberland Bell Telephone Company's Evansville office. This was another sector of the local economy in which female workers became prevalent. The city's first telephone directory was issued in 1881.

Pictured here are ushers at the Grand Theater, about 1900. Ralph Dannettell, son of the former mayor, is standing in the rear, second from the right.

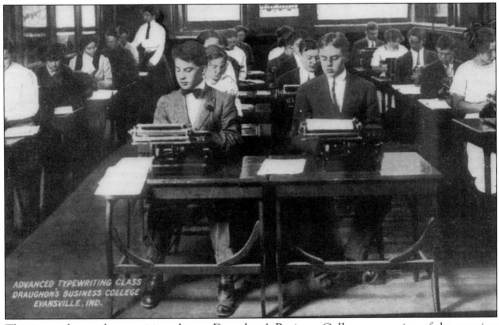

This is an advanced typewriting class at Draughon's Business College—one sign of the growing importance of skilled clerical workers in the industrial city. Typing was clearly not yet gender-defined. (Courtesy of Willard Library.)

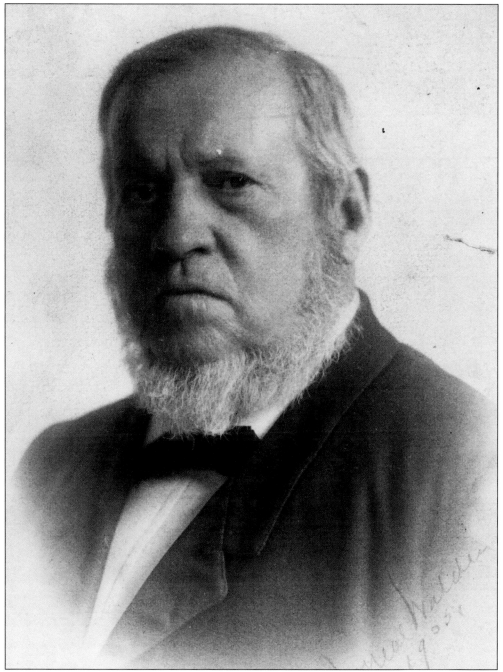

Thomas E. Garvin is pictured here in 1905. Garvin, an attorney, was one of the most eminent civic leaders of the time. A native of Gettysburg, Pennsylvania, like many young men he came to Evansville because of fortunes that many expected to make when the canal was completed to Evansville. He studied law with fellow Pennsylvania transplant Conrad Baker, later governor of Indiana. A Democratic Party activist and entrepreneur, he was a longtime friend and associate of entrepreneur and philanthropist Willard Carpenter. A city street and a park are named for him.

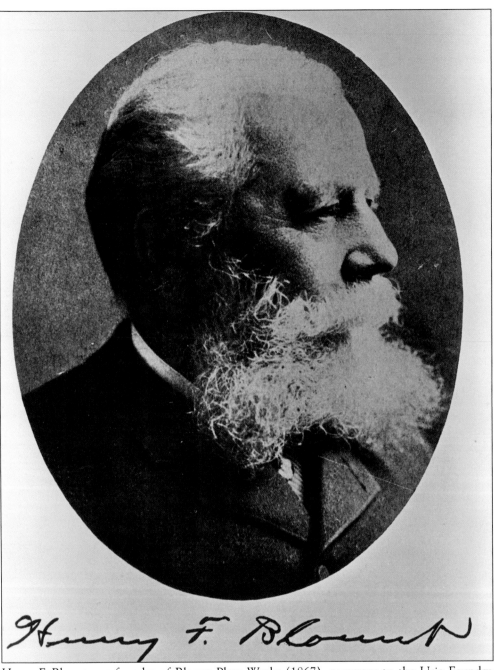

Henry F. Blount was founder of Blount Plow Works (1867), successor to the Urie Foundry. Blount, who was born in New York in 1829, came west to seek his fortune and settled in Evansville in 1860. After seven years of working in foundries, he established his own firm, eventually one of the Midwest's largest. Blount became prominent in civic endeavors as well as other business enterprises. Like other wealthy men of his time, he displayed his success by taking his family on a two-year grand tour of Europe in 1886. In 1888 he purchased a mansion in the Georgetown section of the District of Columbia. Each year he returned to Evansville to visit his factory and have dinner with his employees on his birthday.

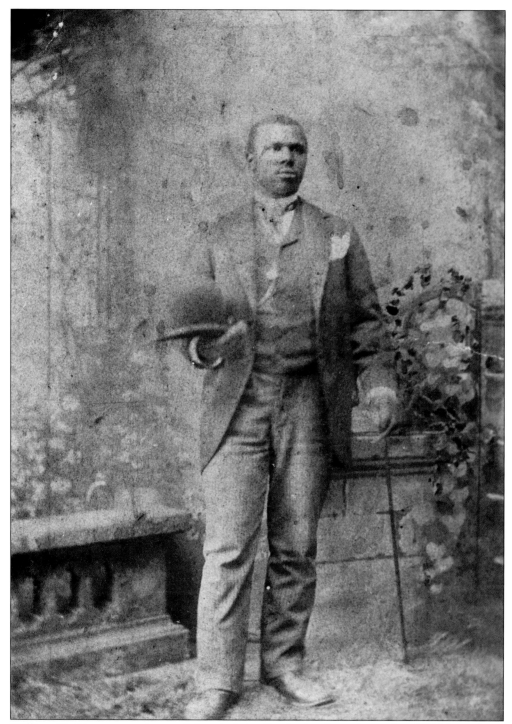

William T. Glover owned one of the city's leading barbershops, located at 317 Upper (now Southeast) First Street, between 1895 and 1929. His clientele was white. Because of the nature of his business, he was one of the members of the African-American social elite.

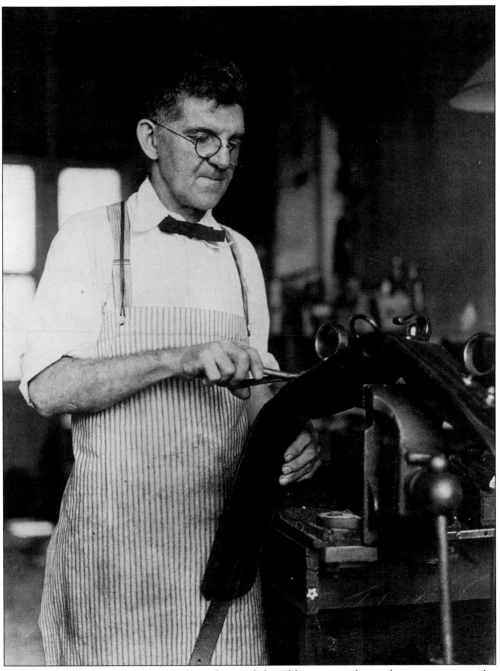

Still another essential craftsman—but destined for oblivion—early in this century was the harness maker.

Three

PEOPLE TOGETHER

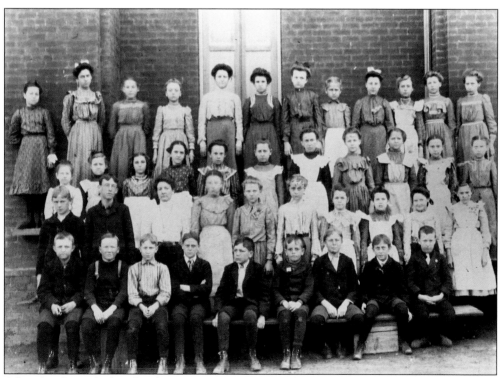

After family and church, the most important social institution was the common (later public) school. These children, of varying ages, were photographed outside their school, but unfortunately they are unidentified. The fact that most are girls suggests evidence of the weakness of child labor legislation at the time.

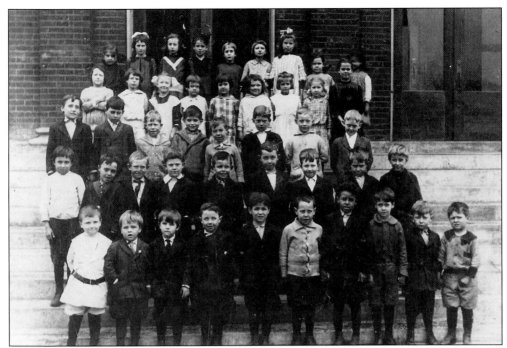

This unidentified group of elementary school children has many more boys than the earlier photograph. The picture captures much of the innocence and optimism of youth, and of that time.

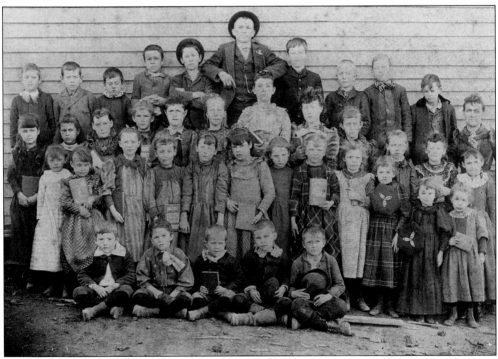

These are probably students of a one-room school on the rural west side of Evansville. These 39 children of various ages were photographed with their teacher (far right, rear) in 1897.

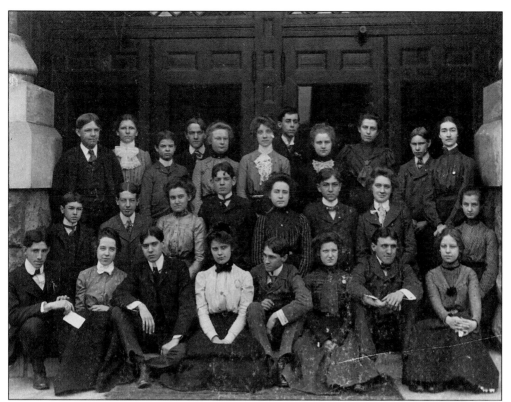

These were the members of the 1909 graduating class of the Evansville High School, the city's only public secondary school until 1917. The curriculum was largely traditional—college preparatory. Few students in the city went beyond grade eight at the time.

Fendrich Cigar workers are pictured here around 1902—six young women and two young men. The firm, located on Main Street until about 1910 when it moved to a lot adjacent to Willard Library, was the city's largest employer of women, who definitely constituted the majority of Fendrich's workers.

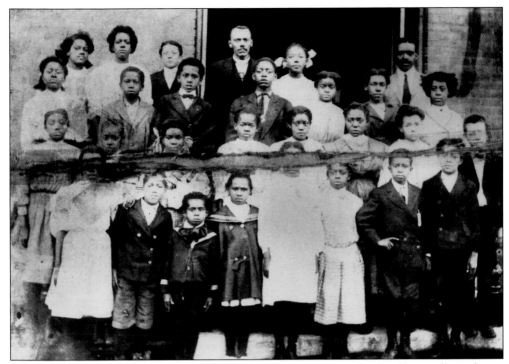

A class at Governor Street School, the largest African-American school in Evansville, is shown here around 1910. Principal P.T. Miller is standing in the center of the last row. Governor, and other black schools, were incorporated into Lincoln School in 1928.

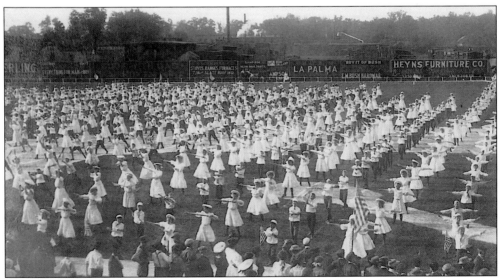

These are Field Day exercises at the Louisiana Street baseball field in 1908. One of the most important legacies of German cultural values, physical fitness for public school students was the province of longtime instructor Julius Doerter.

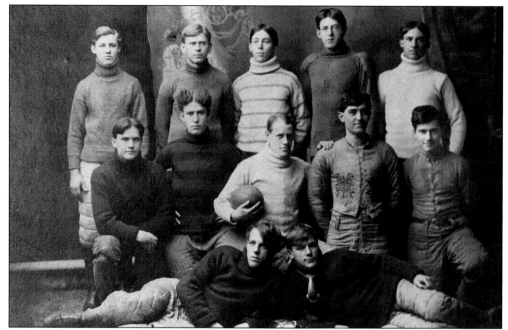

Shown here is the Evansville High School football team of 1903. Interscholastic competition in this sport began at Evansville High School in 1896.

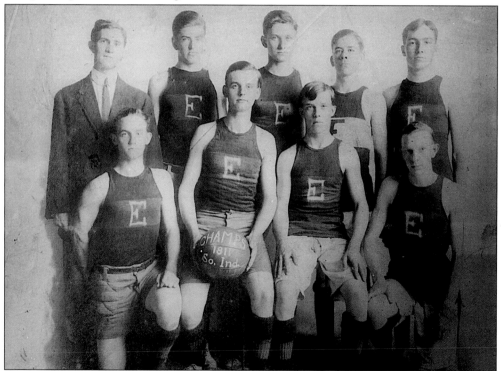

The Evansville High School basketball team of 1911 is pictured here. The first team was formed in 1892. Regular interscholastic competition was gradually introduced. (Courtesy of Willard Library.)

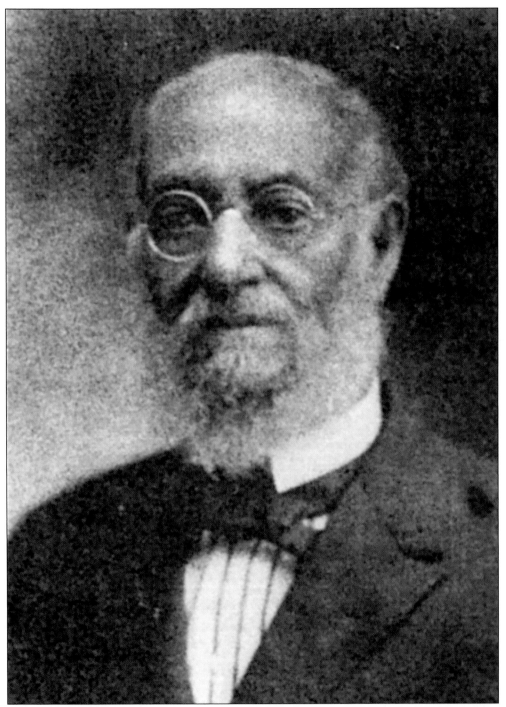

John R. Blackburn Jr., a Dartmouth College graduate, was one of two principals of Evansville's African-American high school between 1890 and 1913. In 1897 the school was moved to Clark Street, near Lower Water. Between 1913 and 1928 it was named Frederick Douglass. Under Indiana law (1869), separate schools for African Americans were permissible. From the outset, Evansville's schools were segregated.

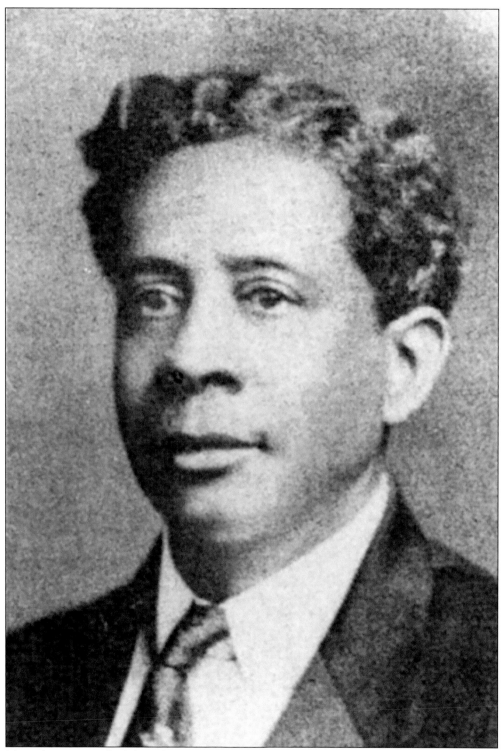

The other principal of the African-American high school during this era was R.L. Yancey, a Fisk University alumnus.

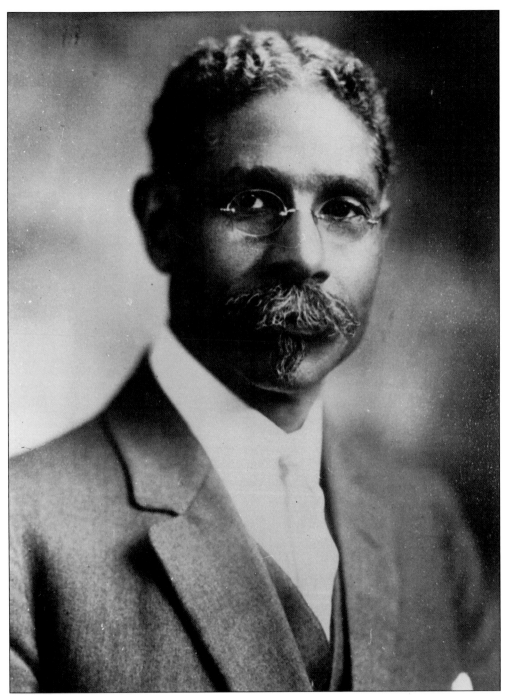

Perhaps the African-American community's leading citizen during this era was George Washington Buckner, who practiced medicine between 1890 and 1943. A Democratic Party activist, he greatly weakened the hold of the Republican Party on former slaves in the city. A former slave himself, the native Tennessean earlier taught school and was principal of Independence School on the west side. President Woodrow Wilson named Buckner minister to Liberia in 1913.

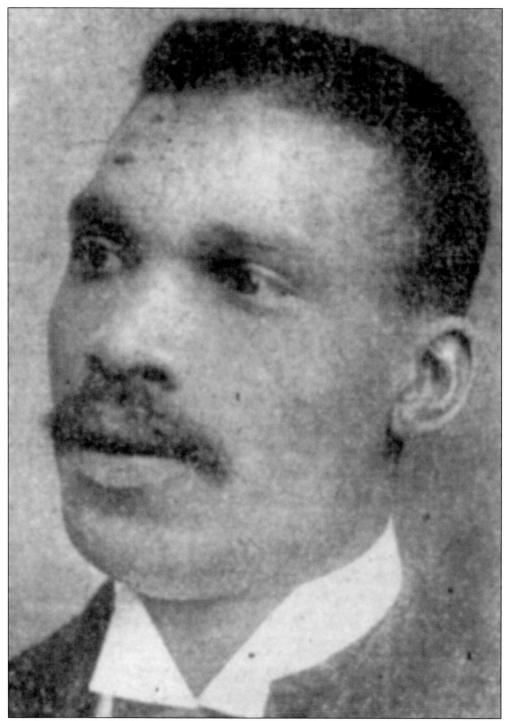

Another prominent African-American leader was S.S. Dupee, who also practiced medicine (between 1899 and 1913) and was active in Republican politics and fraternal organizations. For many years he wrote the weekly column that the Republican *Journal-News* allocated to news from the African-American community.

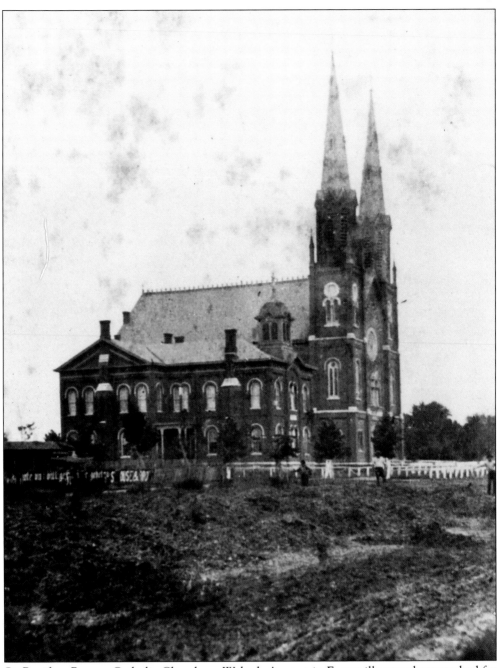

St. Boniface Roman Catholic Church on Wabash Avenue in Evansville was photographed for stereopticon slide viewing shortly after the edifice, one of the largest and grandest on the lower Ohio, was completed in 1881. Its parishioners were largely German immigrants who worked in west side furniture factories and other wood processing works.

Liberty Baptist Church, at Seventh and Oak Streets, was rebuilt after a windstorm severely damaged the church in 1886. The largest African-American congregation at the time, its pastor from 1882 to 1929 was former slave J.D. Rouse, who came to the city in 1865—the year that Liberty was organized. Liberty, the first African-American Baptist church in Evansville, was formed in March 1865.

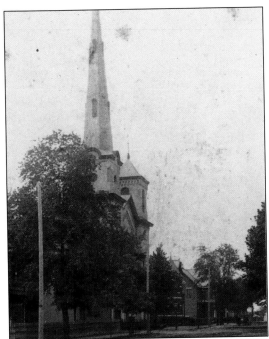

The Walnut Street Presbyterian Church, photographed in 1897, traced its roots to the "little church on the hill," the city's first church (1821). National theological divisions in 1837 produced a local schism. Grace Presbyterian split off, forming the local "old school" branch. Both churches boasted membership from the city's elite. The two eventually reunited.

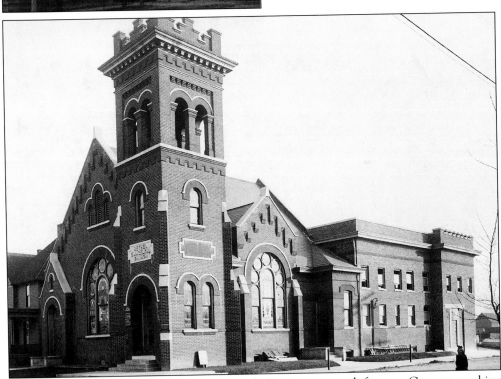

Bethel Evangelical Church, at Jefferson and Garvin, emerged from a German-speaking church (St. John's) because of upwardly mobile businesses and professionals (1906). It was "Americanized" from the outset—the English language was used in business, instruction, and worship. German was common in most Evangelical, Lutheran, and Catholic churches at the time.

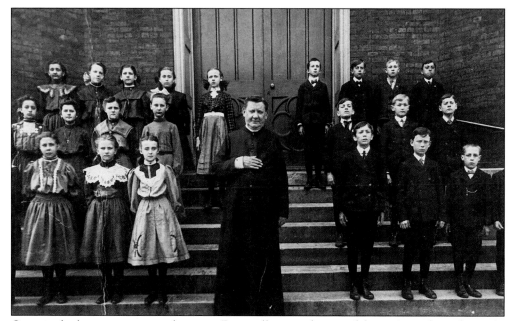

Organized religion was essential to most Evansvillians in the age of the young industrial city. As elsewhere, ethnicity—in this case German—was perceived as a guarantor of orthodoxy. These are members of the 1906 class of first communicants at St. Mary's Catholic Church, with Father Joseph Dickman.

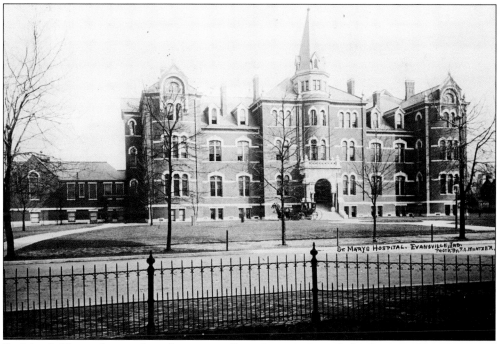

St. Mary's Hospital moved to this site on First Avenue, near Columbia, in 1894. Organized in 1872 by the Daughters of Charity, St. Mary's would remain here until 1956, when it relocated on outer Washington Avenue. The first St. Mary's was near the Ohio in the old Marine Hospital.

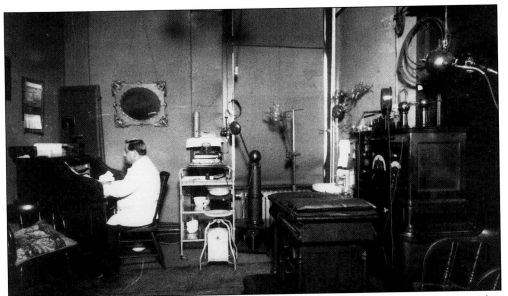

Dr. Charles F. Cluthe, photographed in his office at 1407 North Fulton Avenue, was a member of a family that was prominent in west side business and civic affairs.

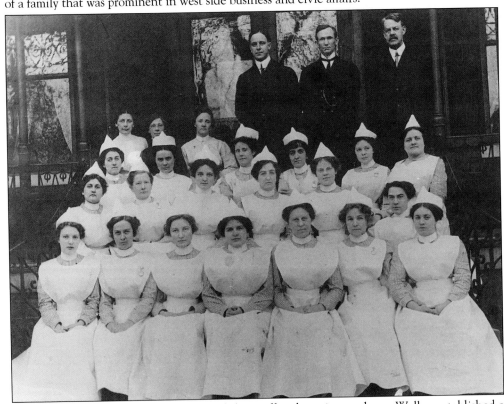

Dr. Edwin Walker was photographed with his staff and nursing students. Walker established a sanitarium on Fourth Street in 1894 that was enlarged in 1914 as Walker Hospital, which in 1944 became Welborn Baptist Hospital. Nurses' training—in this case the area's first—was part of the growing medical professionalism at the turn of the century.

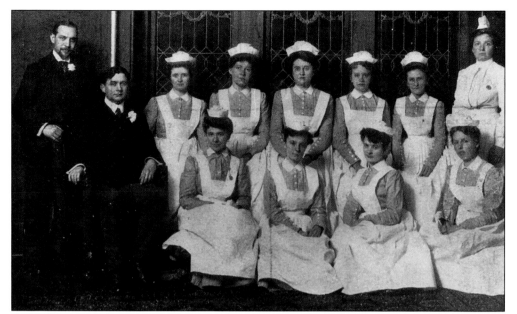

Dr. William H. Gilbert and nurses were photographed at his sanitarium at the corner of Harriet and Michigan Streets in 1897. The sanitarium was moved around 1910 to a three-story, thirty-room hospital at Riverside and Walnut.

These are Deaconess sisters, the heart of medical care at Deaconess Hospital, formed in the early 1890s. The hospital was closely affiliated with the city's many Evangelical Synod of North America (German) churches.

71

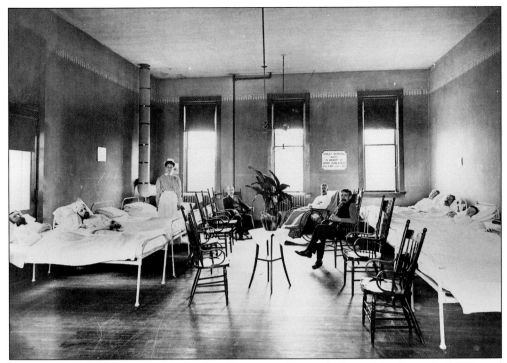

This was the Ashley Memorial Ward at Deaconess Hospital, formed in the early 1890s and photographed around 1910. Going to the hospital at that time was considered a rare and often terminal experience.

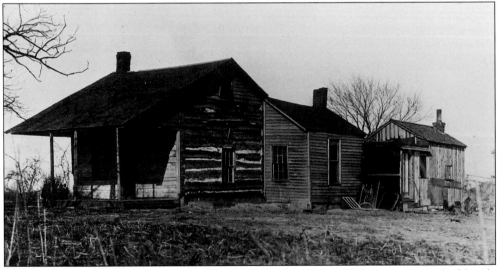

This log home was in the then-remote Knight Township. Before WW I, city limits had barely reached Kentucky Avenue. Living conditions were primitive, but at the same time most homes in the city even lacked indoor plumbing and running water. This residence was razed in the 1920s to make way for Washington Terrace.

German Jewish clothier Moses Strouse is pictured holding his sister-in-law and brother-in-law, Florita and Leslie Eichel, after his wedding to their sister in the 1890s. Strouse's, formed in 1868, remains a mainstay of Evansville's downtown. "Mose" was highly regarded for his civic spirit. He died, at 90, in 1966. Florita and Leslie achieved prominence in art and journalism, respectively.

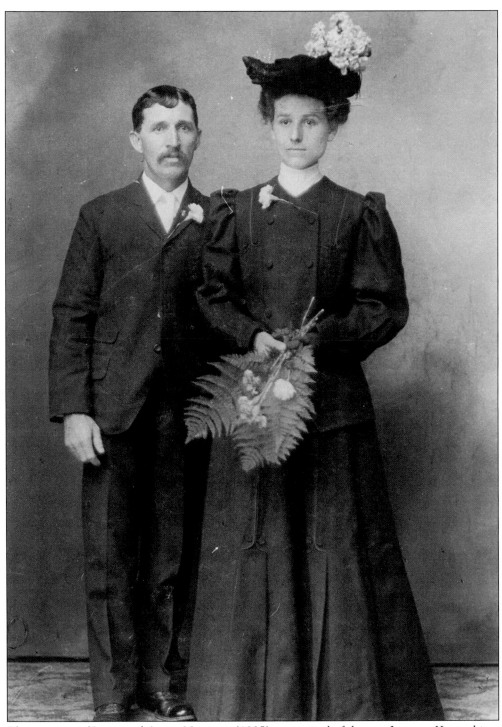

The marriage of James and Annie Newman (1905) was typical of the era. James, a Kentuckian, worked at Igleheart Mill. He met Annie, a second-generation German American, through her father, also at Igleheart. James was chief of maintenance for 45 years. Their son Fred would become president of Old National Bank.

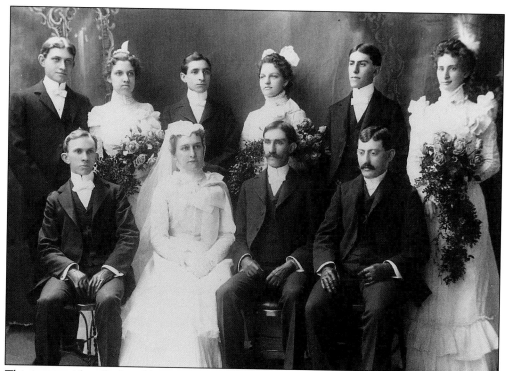

This is an unidentified wedding party, photographed in the late 1890s.

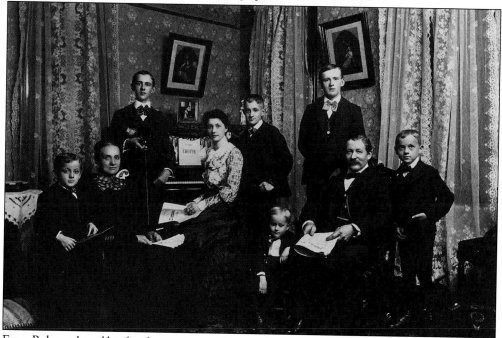

Ernst Bohnsack and his family are pictured here in the 1890s. An immigrant, he owned a butcher shop and resided on the 1100 block of East Columbia. This photograph reveals much about middle-class German immigrant expectations and achievements—for example, the importance of musical training for Bohnsack's children.

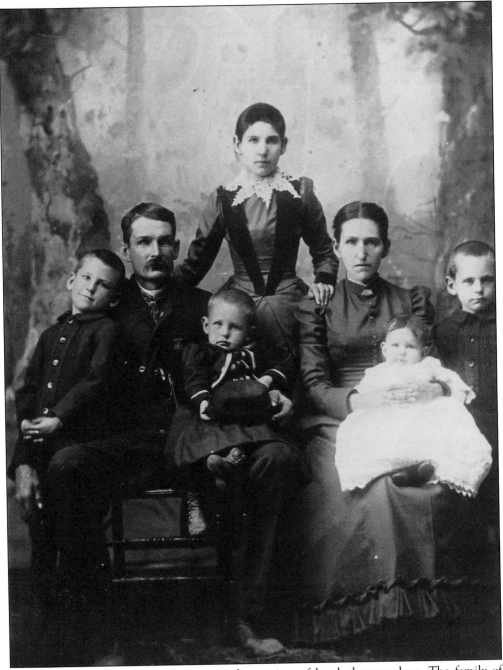

Common folk increasingly had access to the services of local photographers. The family of this unidentified worker was photographed by J.W. Ecker at his Sunbeam Gallery located on Main Street.

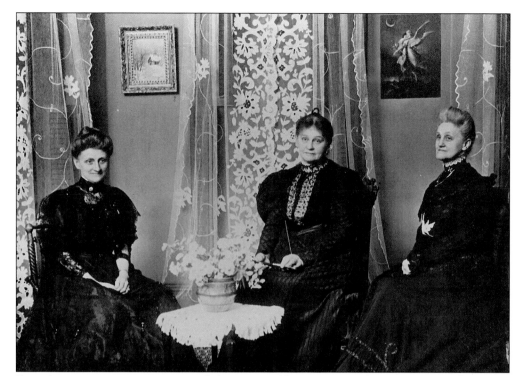

Formal entertainment was essential for respectable women in the Victorian age. Mrs. H. Thornton Bennett, wife of the publisher of the city directory, welcomed guests to her home at 45 Washington Avenue, a residence in a district east of downtown that marked its occupants as members of the upper social strata.

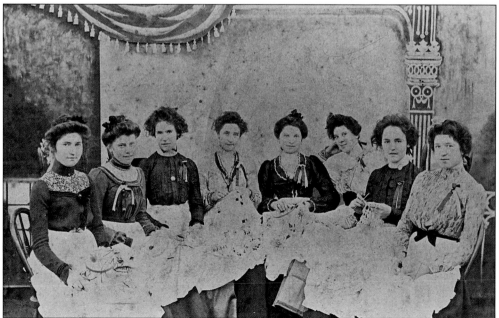

Sewing circles among young and older women provided vital social, as well as philanthropic, links in the late Victorian era.

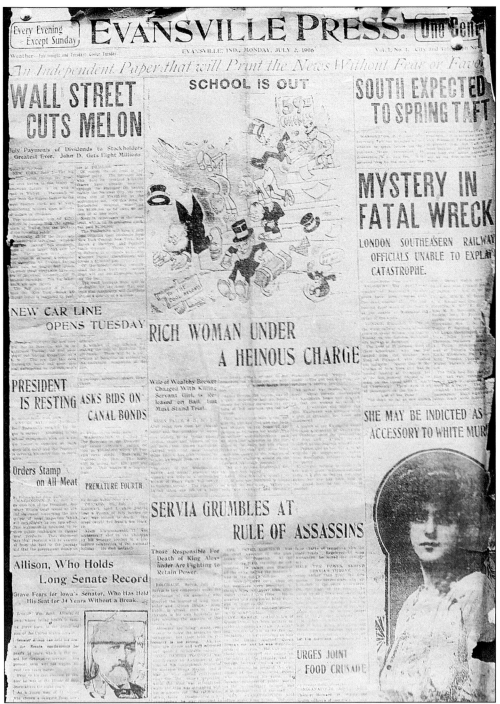

The first issue of the *Evansville Press*, an E.W. Scripps afternoon paper, appeared on July 2, 1906. The *Press* was the only one of four dailies unconnected with local political parties. Under editor F.R. Peters, who guided it in its first three decades, the paper was an independent, progressive force for community good. References to Serbian and Balkan problems on page one would not seem unusual to a late 1990s reader.

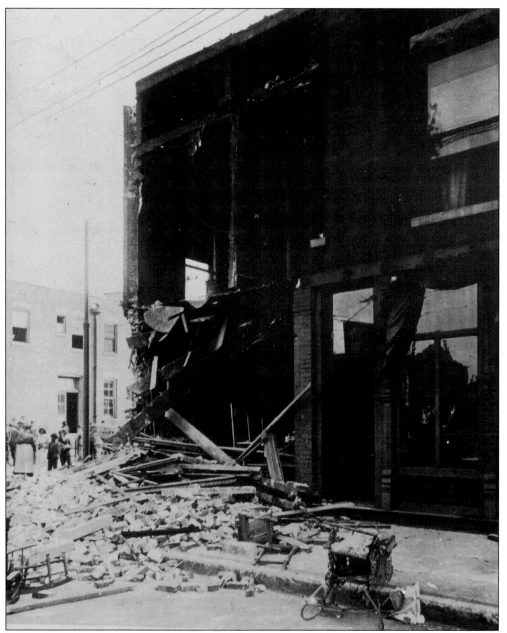

Labor-management disputes became an increasingly common occurrence in industrial cities. Evansville was no exception. During a protracted dispute involving street car workers in May 1907, one non-union operator lost control of his trolley at Eighth and Main Streets. This was the result.

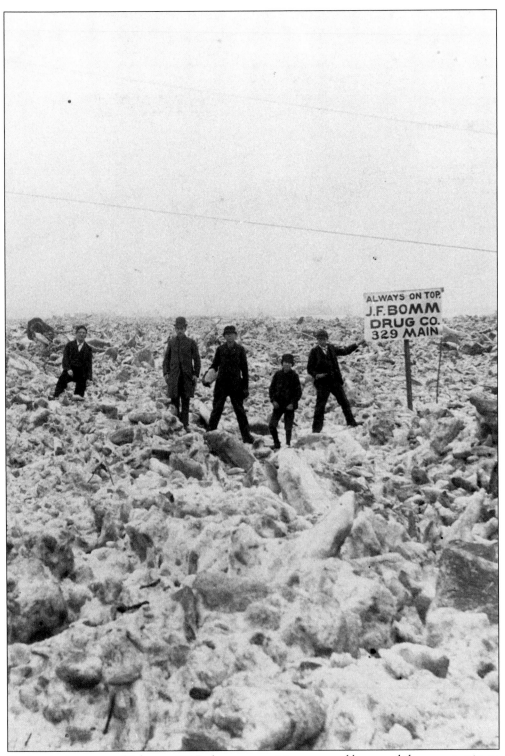

During the ice gorge of February 1897, these enterprising men and boys used the opportunity to promote J.F. Bomm Drugstore of 329 Main as "always on top."

Four

CUSTOMS AND MANNERS

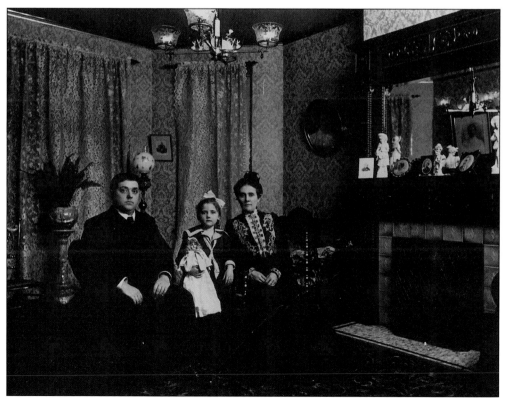

This is the interior of a relatively affluent German family home. It was the residence of Adolph B. Reitz, son of wood miller Clemens Reitz and president of the Reitz-Spiegel Furniture Factory. The house was located on Edgar Street.

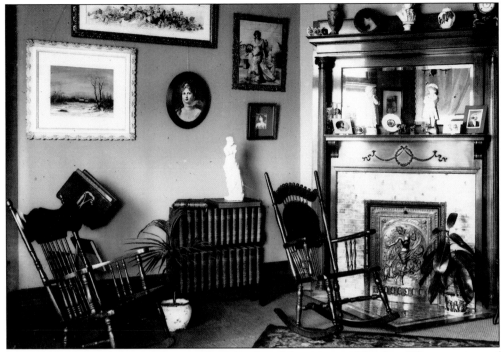

These photographs help to document the lifestyles of the rising middle class. They are views of the parlor or library of an unidentified residence on the near north side of the city.

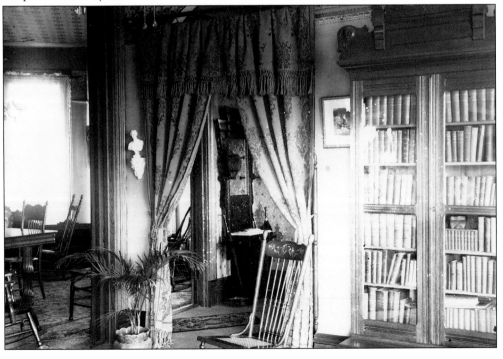

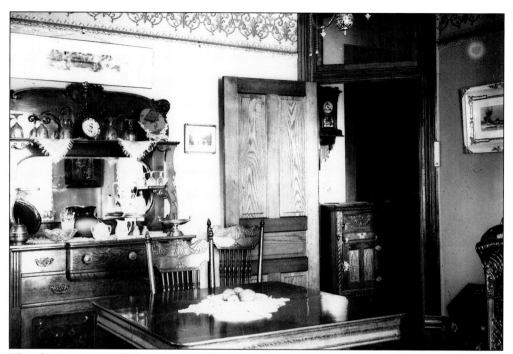

The dining room of the same residence on the previous page was documented in the photograph above.

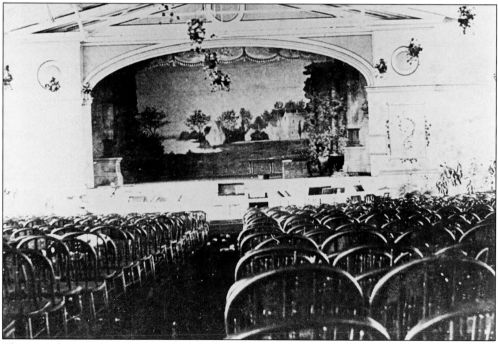

This was the interior of Evans Hall (1879), the city's largest public gathering place until the opening of the Coliseum in 1916. Presently the site of Central Library, Evans Hall was dedicated to the cause of temperance by Saleta Evans, wife of the city's namesake, whose sons killed each other in a drunken brawl.

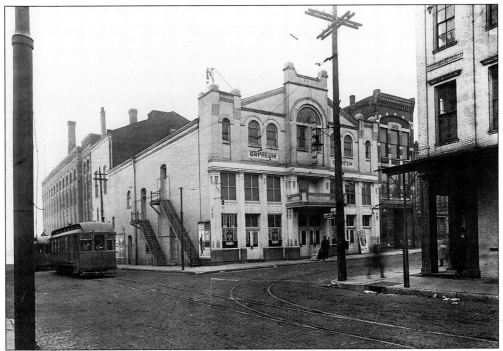

Known shortly before its demise, around 1910, as the Orpheum Theater, this was for many years known as the People's Theater. The site at First and Locust Streets was once that of the Evansville Opera House (1882). Drama, vaudeville, concerts, lectures, and opera were offered here.

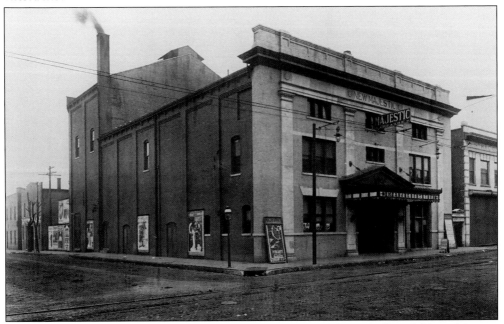

The Majestic Theater was built on the former site of the Igleheart Mill at Fifth and Locust Streets. The mill was relocated near the Belt Railroad on First Avenue in 1910. The Majestic was one of downtown's grandest venues for the relatively new motion pictures.

Progress Hall, on Fifth Street, was one of a growing number of public meeting halls that had been constructed by the 1890s.

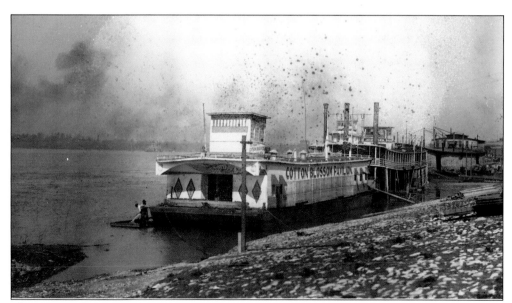

The *Cotton Blossom*, a showboat, provided river-borne entertainment not only for Evansville but other communities on the lower Ohio in the summer.

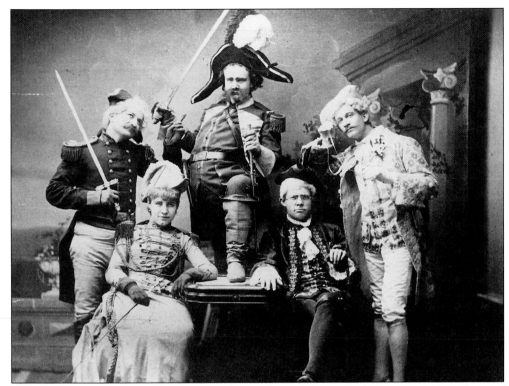

"High culture"—amateur as well as professional—was increasingly seen as an attribute of growing cities. Performers in this 1890s production of *The Grand Duchess* included a number of notable citizens, including Charles Covert (seated, right), mayor from 1901 to 1906.

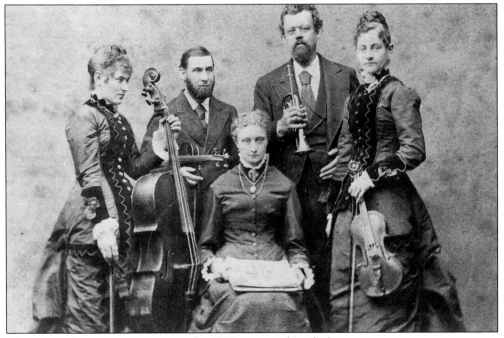

This group of amateur musicians in the 1890s was unidentified.

Second Grand Concert,

⌐OF THE⌐

Evansville ❋ Philharmonia,

AT

GERMANIA HALL.

HAYDN'S ORATORIO OF

"THE ❋ CREATION"

Monday Evening, November 9, 1891.

SOLOISTS:

MRS. WM. IRICK,	} SOPRANI.	MR. CHAS. BROMM, TENORE.
MISS JENNY BREITSCHU,		MR. ADAM BROMM, BARITONE,

MR. G. M. DAUSSMAN, BASSO.

Full Orchestra of **25** pieces specially selected for this occasion from our best amateurs and from our own Warren's First Regimental Band and the famous Ringgold Band, of Terre Haute.

Mis Sadie Stoltz,...Pianist.

JOSEPH CINTURA, ⌐ ⌐ Director.

The program of the Evansville Philharmonia of November 8, 1891, is a vivid reminder of the legacy of German immigrants and their descendants to the making of "high culture."

Benefiz-Concert des Zither Virtuofen
HANS BOECK,
Sonntag, den 24. April, in der Liederkranz Halle,

unter gefälliger Mitwirkung des

Frl. H. Sihler (Sopran), **der Herren Determann** (Tenor), **Süß** (Komiker), **und des Evansville Zither-Club.**

PROGRAMM.
Erster Theil.

1. Grüße der neuen Welt! Marsch über amer. National Melodien v Hans Boeck
 Evansville Zither-Club.

2. XIV. Concert Fantasie v . C. Umlauf
 Zithersolo: Hans Boeck.

3. Mein Engel, Lied v . Esser
 Tenorsolo: Herr Franz Determann.

4. Erinnerung an die Reise nach Egypten, Pottpourie v Huber
 Zither Duett: Frl. Hulda Illing u. Hans Boeck.

5. Das Alpen Horn, Lied v . Proch
 Sopransolo mit oblig. Waldhornbegleitung: Frl. Sihler u. Herr Theodor Verges.

6. s'Wiener Frücht'l . Komische Soloscene
 Herr Süß.

Zweiter Theil.

7. Der Elfe Traum, Concert Reverie v . Umlauf
 Terzett: Die Herren Boeck, Kaltofen u. Rahm.

8. Das kleine Wort, Lied v . Beyer
 Sopransolo mit oblig. Zitherbegleitung: Frl. Sihler u. Hans Boeck.

9. D'G'vatter Bitt'! . Komische Duoscene
 Die Herren A. Illing und Emil Kaltofen.

10. Gavotte v . Kniepp
 Evansville Zither-Club.

Anfang, 8 Uhr.

This was the program for a zither music concert at Liederkranz Halle, near Division Street, c. 1900. Liederkranz was one of two large halls built for German maennerchor (men's choirs).

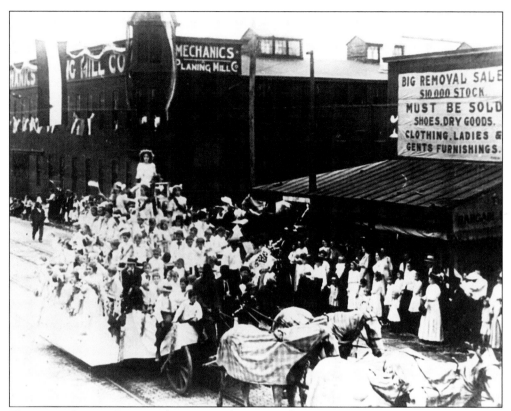

This was a German Day parade near North Main and Iowa Streets in 1908. German Day was organized by the city's German elite around 1890 to celebrate German cultural, intellectual, and technological achievements. After the Fourth of July, this was the most prominent civic celebration annually until WW I ended it. The Germania Maennerchor's annual Volksfest is a legacy of those days.

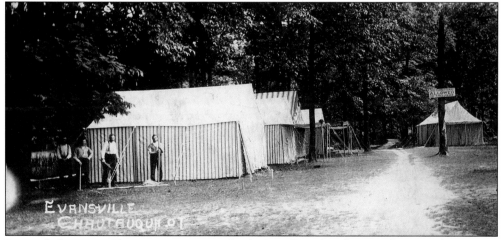

Pictured above is a Chautauqua camp on Coal Mine (Reitz) Hill, around 1908. Chautauquas provided a distinctive form of adult education in the late 19th and early 20th centuries. Popular speakers and entertainers did the Chautauqua circuit. Evangelical Protestant religious education was a vital element.

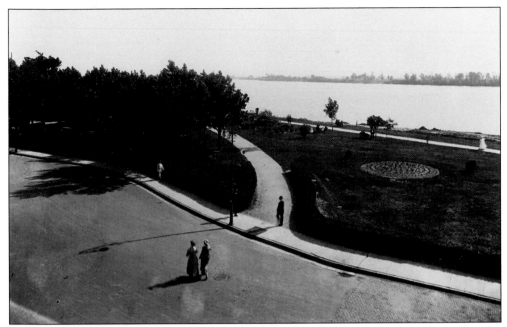

Sunset Park, on Upper Water Street, adjoining the city's most affluent residential area, was the city's most widely used public space in the late Victorian era.

Garvin's Grove, a popular gathering place on the north side, became the entryway to Garvin Park, and was added to the city park system during the first term of Mayor Benjamin Bosse (1914–1922). It was named for its donor, Thomas Garvin. (Courtesy of Willard Library.)

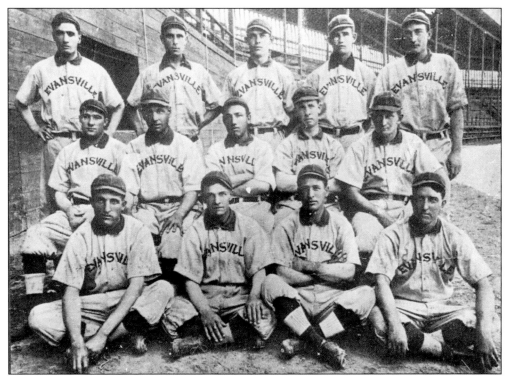

This photograph of the Evansville "Evas," champions of the Central League in 1908, graced many Fendrich Cigar Company boxes. Champion athletes were commonly displayed on tobacco products. Evansville had had professional baseball teams since the mid-1870s.

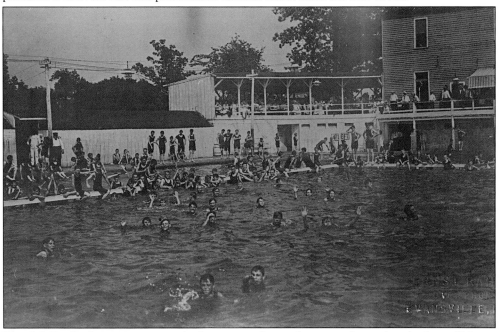

The Salt Pool, a longtime summer bathing resort for residents, was located at the foot of Mount Auburn Hill on the west side.

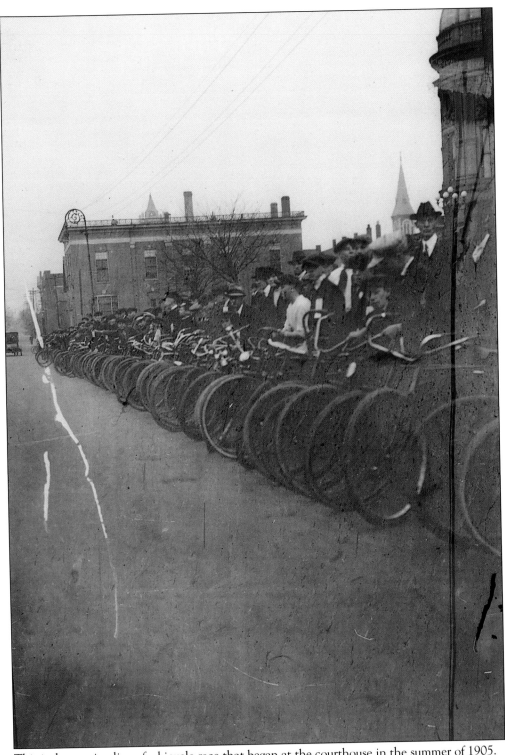

This is the starting line of a bicycle race that began at the courthouse in the summer of 1905.

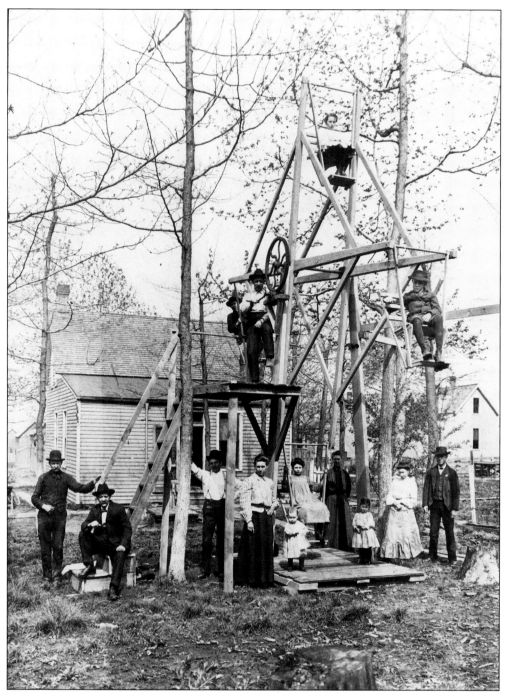

Recreation at the turn of the century was generally informal. Henry Broeker, who lived on Leslie Street on the west side, built this Ferris wheel in his backyard for use by relatives and neighbors. In this 1907 photograph, his son-in-law, James Newman, is cranking the device.

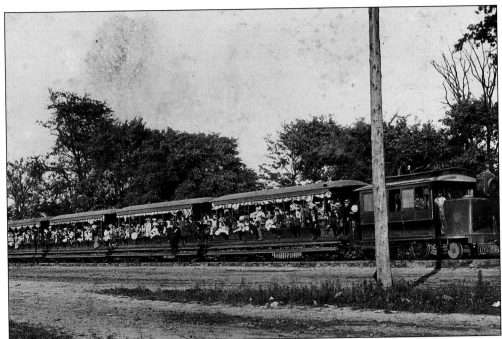

For many, summer was not complete without an excursion on the open summer cars of the "Dummy Line" (the Evansville, Suburban, and Newburgh interurban) to Barnett's Grove, a popular picnic spot north of the present intersection of Washington and Lincoln Avenues.

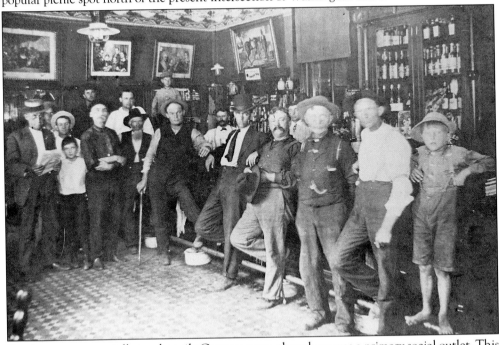

For the masses, especially in a heavily German town, the saloon was a primary social outlet. This group was photographed in Joe Folz's Saloon at First Avenue and Columbia Street. Patrons were workers in the area's packing house, stockyards, and furniture factories. Saloons outnumbered churches by 300 to 75.

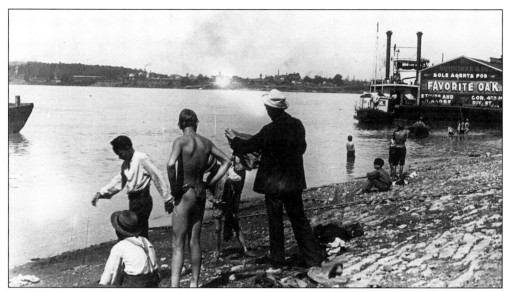

Swimming in the Ohio offered summertime recreation for the adventuresome of all ages, despite threats posed by passing boats, floating debris, deep water, and swift currents.

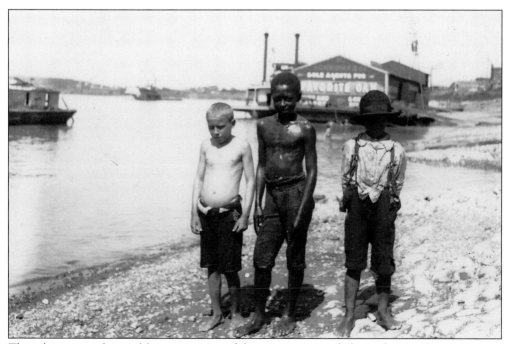

These boys seem thoroughly appreciative of their summertime frolic at the riverfront.

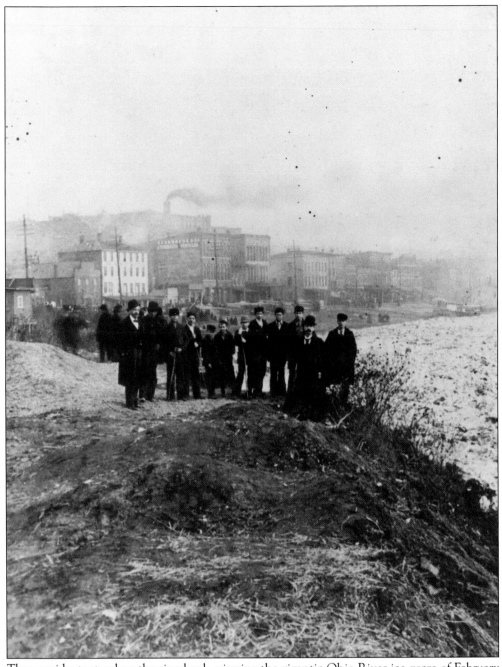

These residents stood on the riverbank, viewing the gigantic Ohio River ice gorge of February 1897. Natural phenomena like these provided entertainment as well as danger.

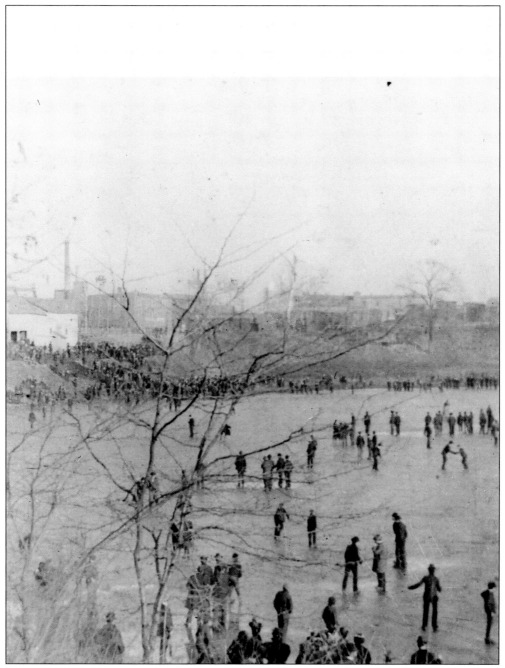

A popular wintertime sport was skating on Sweetser Pond, near the mouth of Pigeon Creek.

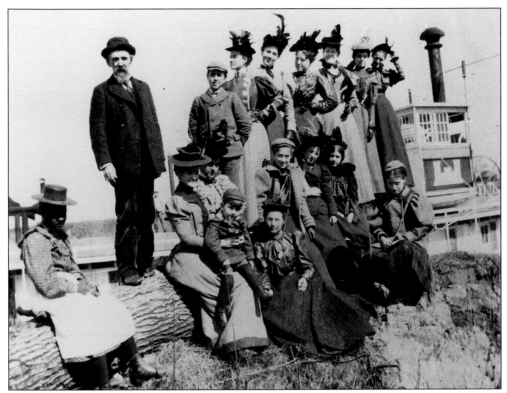

The Ohio River offered people in Evansville and the Tri-State many recreational outlets. Here an unidentified group, probably members of a family with relatives or friends of one of the children, was photographed on the riverbank around 1895. The young African-American woman may have been a household servant.

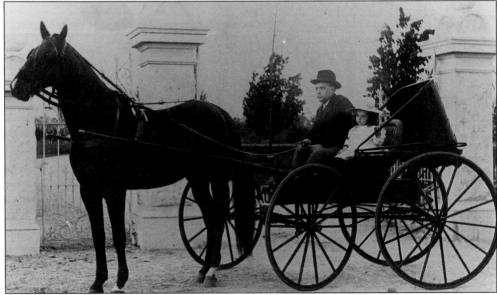

Adolphia B. Reitz and Eleanor Reitz (later Nickels) were photographed in the family's horse-drawn carriage.

An unidentified boy was photographed filling his sprinkling can at the family's backyard well, undoubtedly to nurture the garden in the background.

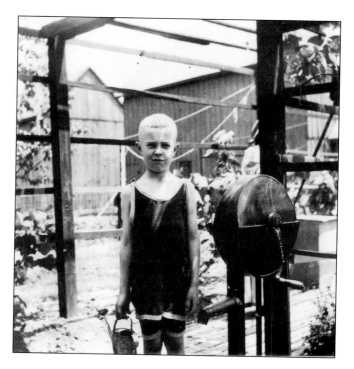

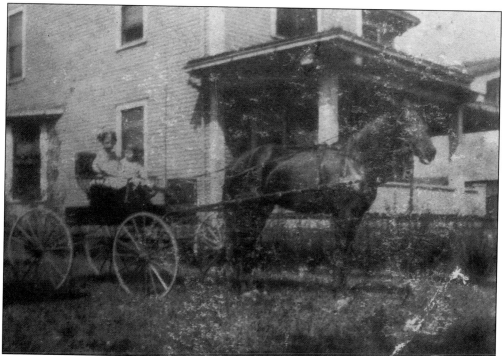

Martha Cox, age nine, was photographed in her grandmother's carriage with horse "Minnie" and Eileen Joyce, age four, in 1910. This was taken in the yard of her grandmother's home at 115 South Barker in Howell. Like young Miss Joyce, whose house is pictured, Miss Cox was the daughter of an L and N locomotive engineer.

Friends might have their photograph taken on a leisurely Saturday afternoon at the Novelty Forth-O-Graf on Main Street. Pictured here, from left to right, are: Florence Dannettell, daughter of the former mayor; Georgia Carpenter, granddaughter of Willard Carpenter, entrepreneur and philanthropist; Edna Curry; Nettie Winfrey; and Nina Curry. Their photo (1895) exuded American innocence at the dawn of the new century.

Young women friends were photographed at an unidentified downtown studio in 1908.

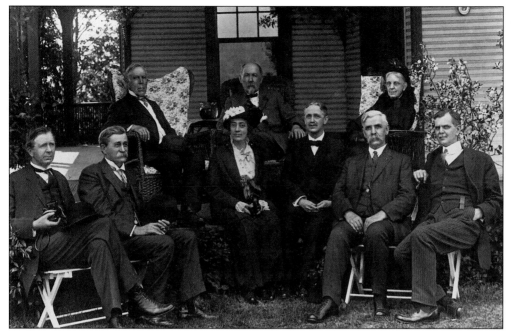

Harriet Audubon of Louisville (center), granddaughter of the famed naturalist John J. Audubon, visited Evansville early in the century. To the right is George S. Clifford, member of a prominent Evansville family. The elder Audubon once resided in Henderson.

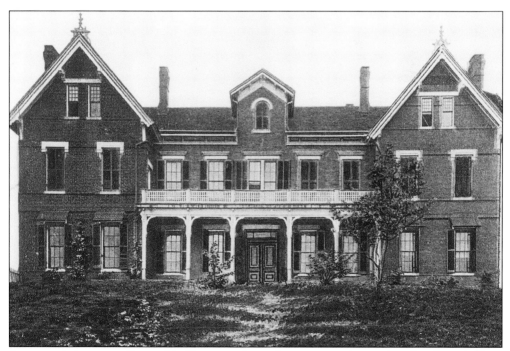

A postcard view, manufactured in Germany, shows the county orphan asylum for white children on West Indiana Street around 1900. Although not racially segregated at first, separation was implemented in the 1880s.

The Evansville City Hall on Third Street, near Walnut, was completed in 1889. The upper part of the tower was taken down in the 1920s. The structure was razed in 1971.

A portion of Oak Hill Cemetery is pictured here in the 1890s. Oak Hill, opened in the mid-1850s, was the city's oldest and largest public cemetery. Its many ornate monuments and open spaces made it both an open-air museum and public park.

The city's first German-speaking Republican mayor, John Dannettell (rear), is shown with friends Jake Arnold, P. Jaefflin (city engineer), and F.J. Scholtz.

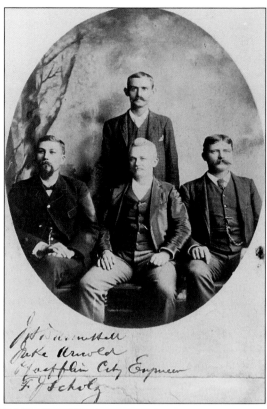

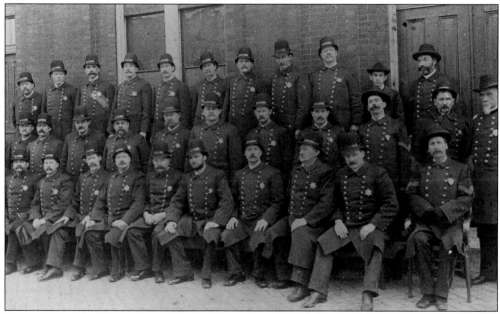

Evansville's policemen were pictured with Mayor John Boehne, Lutheran layman and frugal Democrat (right), in 1906. Boehne diligently attempted to clean up the vice that predecessors found politically and financially rewarding. He resigned in 1908 after his election to Congress. Controller John J. Nolan, the city's first Roman Catholic mayor, replaced him.

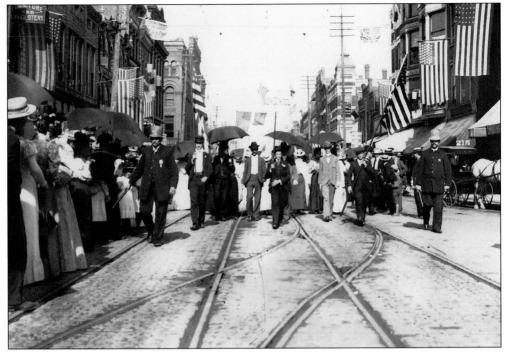

These photographs document the jubilant scene on Main Street in mid-summer, 1898, as Evansville citizens celebrated the ending of hostilities in the war with Spain. Begun in April, this short-lived war had enormous consequences for American society as well as diplomacy and military policy.

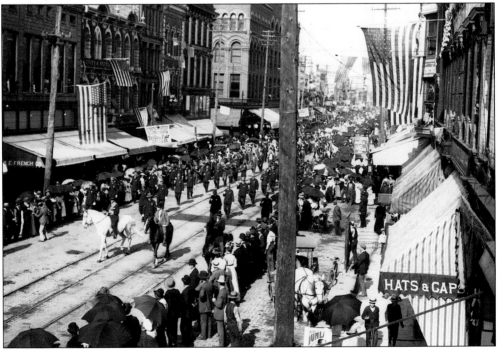

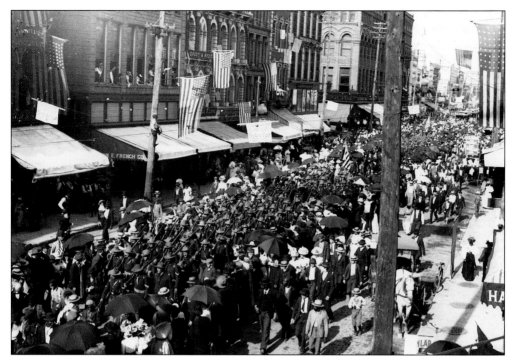

This is another scene from the parade in July 1898. It was perhaps the largest parade in 19th-century Evansville history.

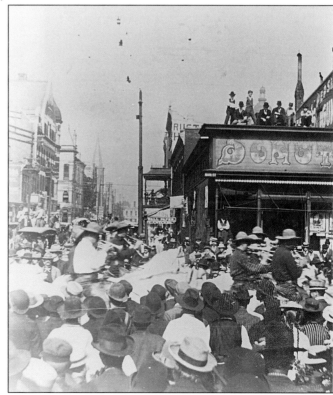

A downtown parade was captured at Fourth and Main Streets, shortly after the war with Spain. The horsemen in the foreground are dressed to resemble Colonel Theodore Roosevelt's "Roughriders."

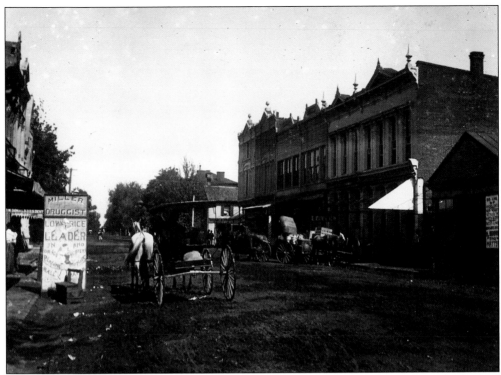

This street scene in New Harmony, 1898, shows the ubiquitous horse-drawn vehicles and small-scale store buildings of the Tri-State.

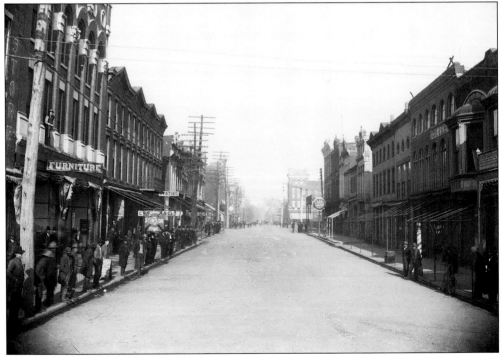

This was Main Street in Mount Vernon, shortly before the beginning of a parade.

Five

THE TRI-STATE

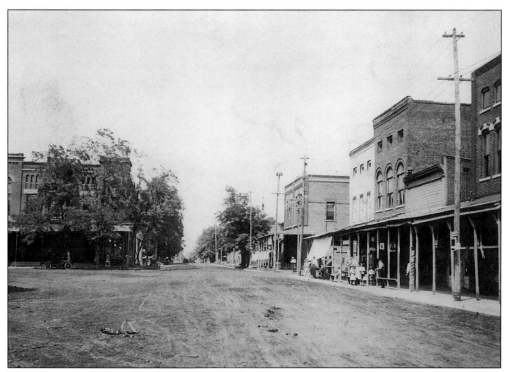

Main Street in Owensville, Indiana, in 1905 was representative of the many small town main streets of the time. (Courtesy of Willard Library.)

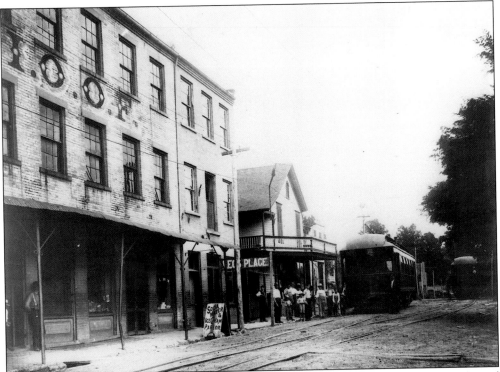

One of the factors that transformed the urban landscape was the interurban, which facilitated urban sprawl. This is the Evansville, Suburban, and Newburgh station in Newburgh, Indiana, in 1907, with a group waiting to board a car. (Courtesy of Willard Library.)

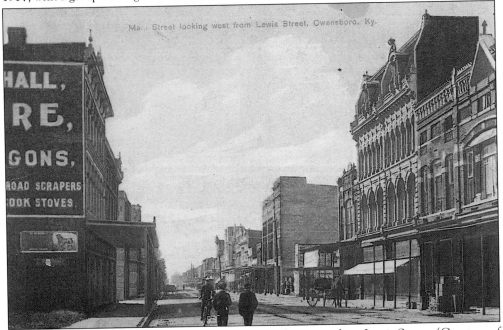

Main Street in Owensboro, Kentucky, was shown looking west from Lewis Street. (Courtesy of Joseph Ford, Owensboro.)

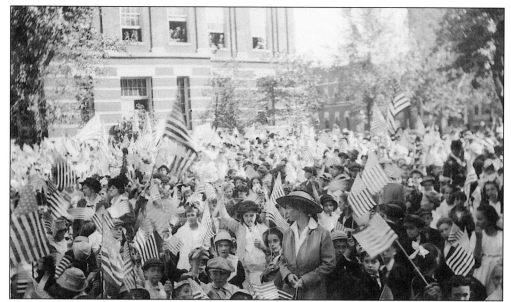

The crowd of youngsters is celebrating Owensboro's centennial celebration in 1897. The observance was based on an oral tradition about the first permanent settler in the area. (Courtesy of Joseph Ford.)

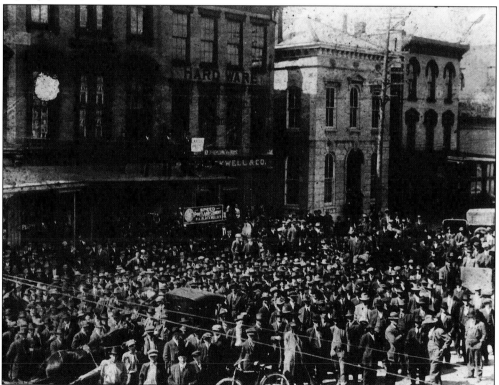

An unidentified public gathering—perhaps a political event—in Henderson, Kentucky, was captured by an unidentified photographer. The two buildings to the right remain standing. (Courtesy of Henderson Public Library.)

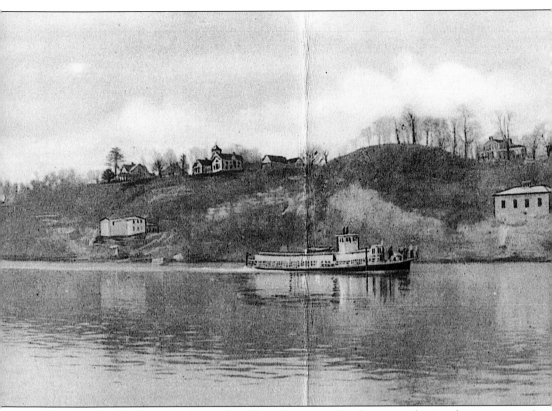

This is the bluff overlooking the Ohio River at Rockport, early in this century. A gasoline-powered boat—the sort that provided trade and communication among small river

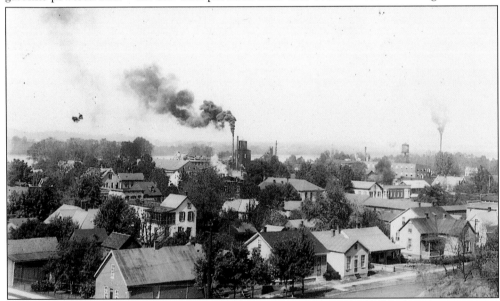

The skyline of Tell City, early in the 20th century, reveals its substantial factory-based economy. Wood products were a mainstay of the Swiss-German community, which was organized in 1858. (Courtesy of Willard Library.)

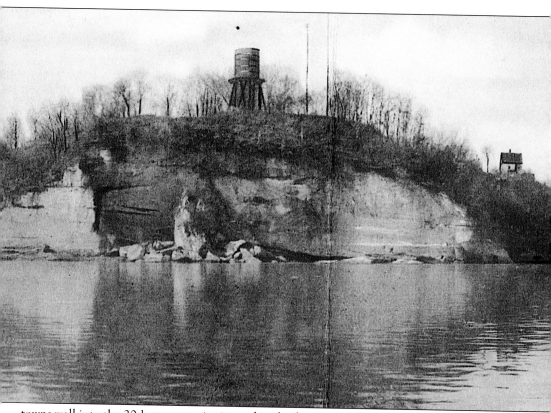

towns well into the 20th century—is pictured in the foreground. Rockport's first settlers erected homes and businesses at the base of the bluff. (Courtesy of Willard Library.)

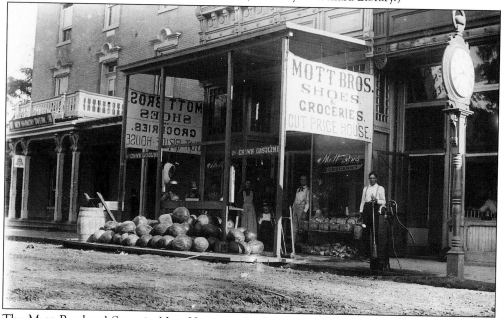

The Mott Brothers' Store in New Harmony, in the summer of 1897, exhibited much of the bounty of local gardens.

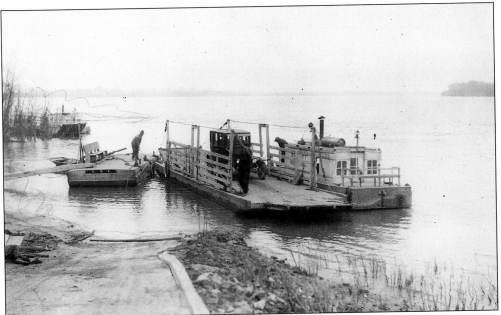

The Rockport Ferry, pictured around 1910, was a vital means of river transit until a bridge was constructed long after WW II. Before the Evansville-Henderson vehicular bridge was completed in 1932, all river crossings between Louisville and Paducah were provided by ferry.

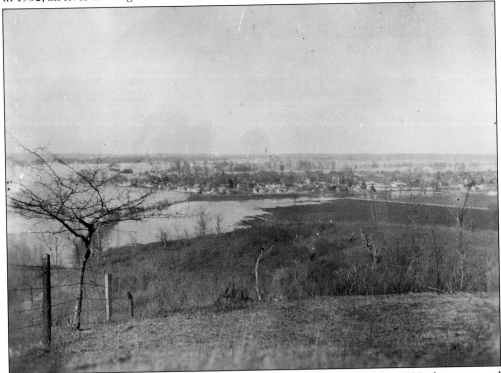

High water on the Wabash River at New Harmony, shown on March 31, 1898, demonstrated how many towns in the area could be isolated at these times. This view was taken from the "Indian Mound," southwest of the village.

These were the locks on the Green River at Spottsville, Kentucky, on the border between Daviess and Henderson Counties. The photograph was probably taken in 1889. The Green has always been a primary commercial corridor in the Tri-State.

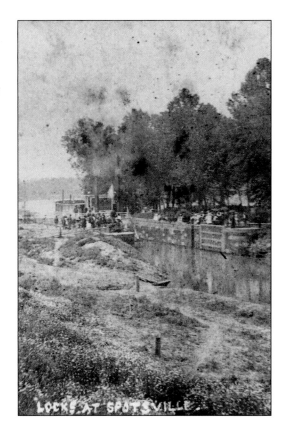

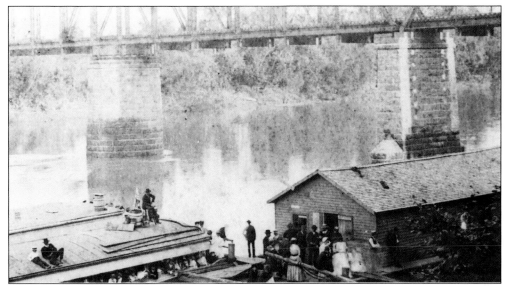

This was the newly constructed railroad bridge at Spottsville. Rail service between Henderson, Owensboro, and the Louisville region was opened in 1889.

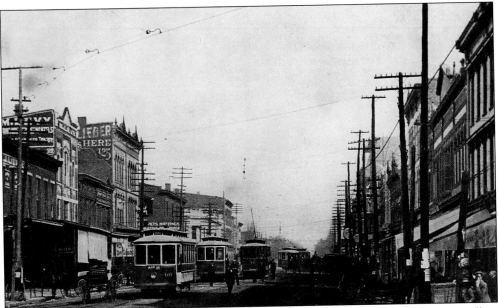

Main Street in Henderson, in the late 1890s, showed all the trappings of a growing city—trolleys (the first introduced in the lower Ohio valley) and electrical and telephone lines. (Courtesy of Henderson Public Library.)

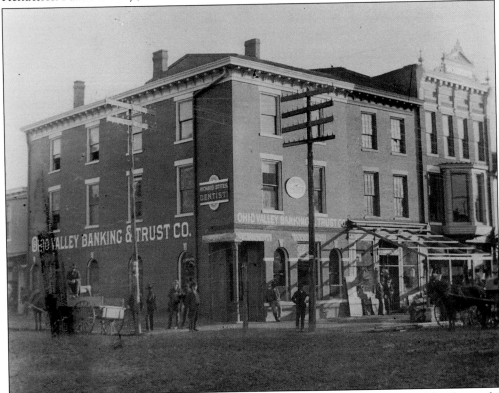

The Ohio Valley Banking and Trust Company has been located at this spot in Henderson for over a century since this photograph was taken. (Courtesy of Henderson Public Library.)

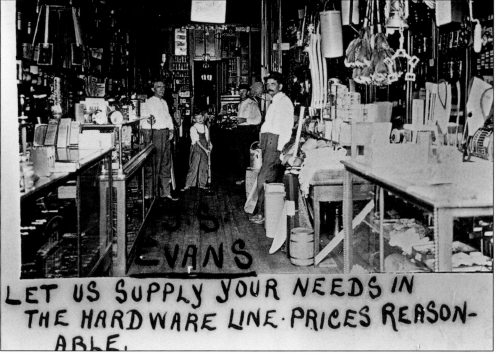

A Mount Vernon photographer began a series of photographic advertisements for local businesses in 1898. This was his effort for the J.S. Evans Hardware Store.

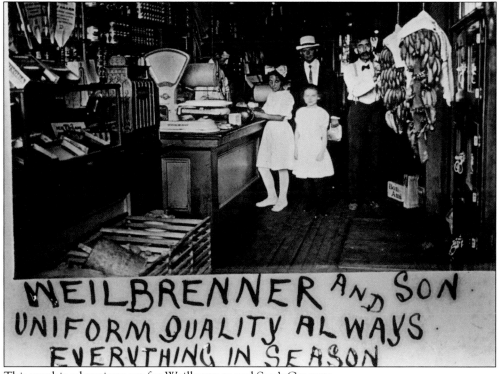

This was his advertisement for Weilbrenner and Son's Grocery.

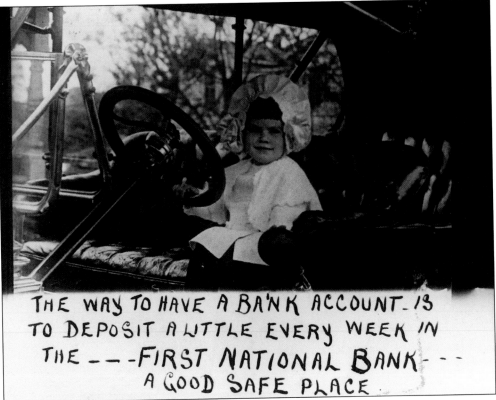

And this was his promotional piece for the First National Bank.

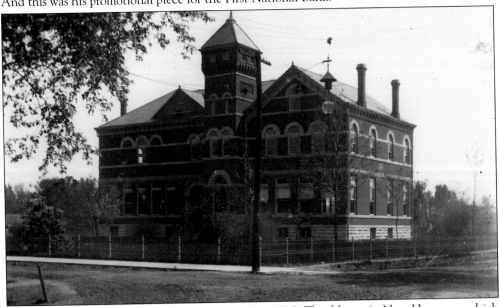

The Workingmen's Institute was photographed in 1906. This library in New Harmony, which William Maclure helped to found in 1838, is the state's oldest continuously operational public library. It is also the only survivor among the 160 other workingmen's libraries funded through his will in 1840.

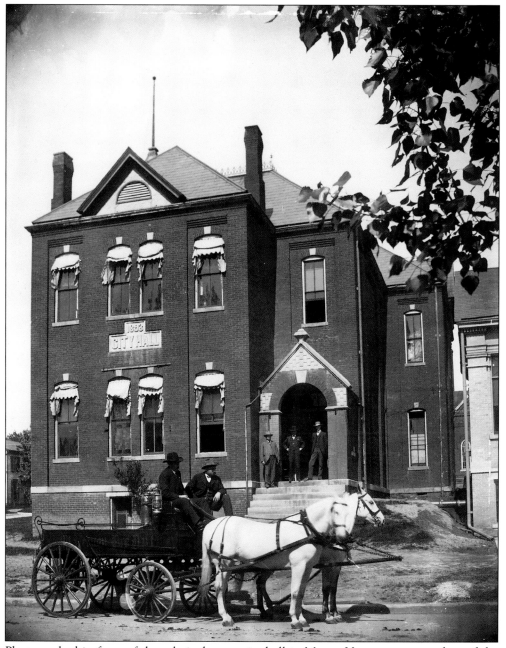

Photographed in front of the relatively new city hall in Mount Vernon were members of the city's growing fire department.

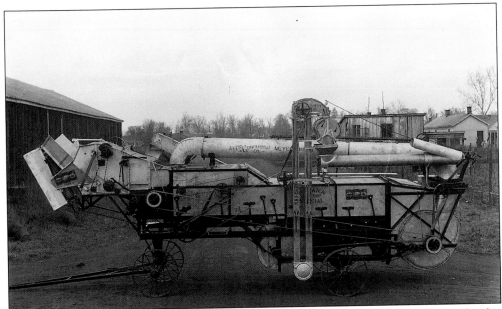

This is a Keck-Gonnerman wheat separator manufactured in Mount Vernon. Power for this machine generally came from steam engines. Keck-Gonnerman, the city's leading industry for many years, traced its roots to a small foundry established in 1873. The firm began manufacturing steam engines, threshers, and portable sawmills in 1884, when the name Keck-Gonnerman was adopted. At the turn of the century it employed two hundred men.

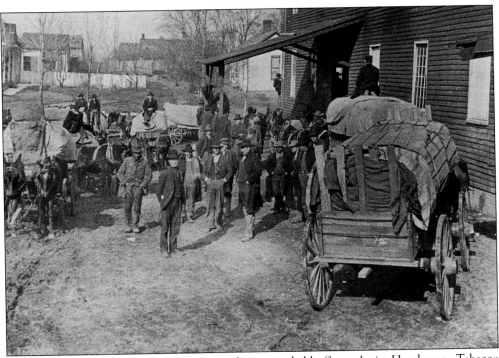

These men are gathered at a tobacco warehouse, probably Soaper's, in Henderson. Tobacco production was central to the Henderson economy from its founding well into the 20th century.

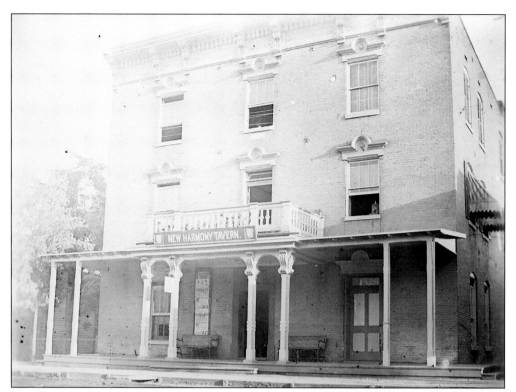

The Tavern, a favorite gathering spot in New Harmony, was formerly Dormitory Number 3 of the Harmonists. It was photographed in the summer of 1897.

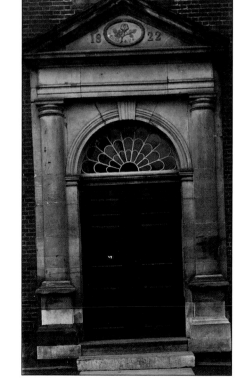

The front door of the Harmonist Church of 1822 was incorporated into the north side of the Harmony School. This was taken on March 9, 1906. When the school was razed, the frame was saved and made the focal point of the town park on Church Street.

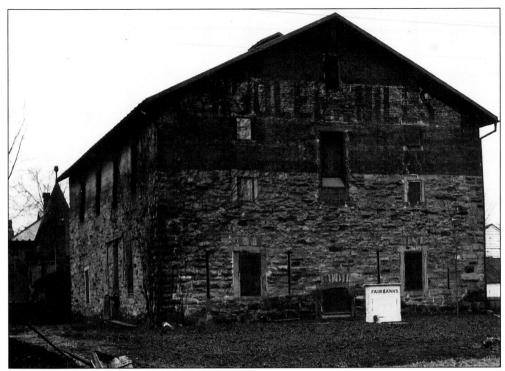

The Harmonist Granary at New Harmony was photographed on March 9, 1906—a vestige of the utopian community (1814–1824). The Granary was restored in the late 1990s.

The old wood frame Episcopal Church in New Harmony was photographed on March 11, 1906.

This was Barney's Prairie Church near Mount Carmel, Illinois. It was architecturally typical of the many rural Evangelical Protestant churches in the Tri-State.

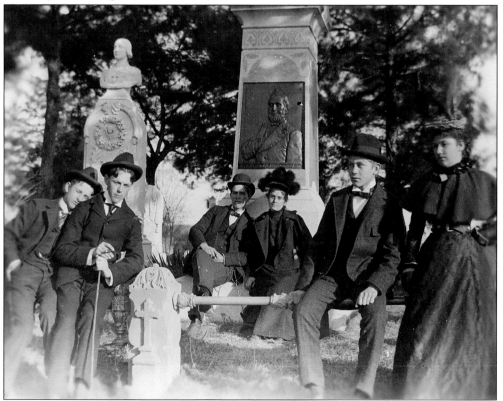

These young men and women are gathered at a prominent memorial in New Harmony's cemetery southwest of the town.

121

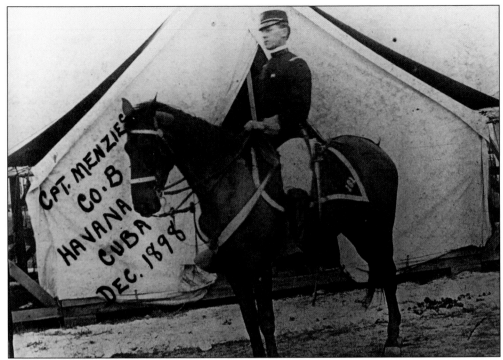

Winston Menzies of Mount Vernon was photographed in Havana, Cuba, in the fall of 1898. Born in Posey County in 1876, Menzies graduated from Indiana University in 1897. A reporter in St. Louis, he volunteered as a private in April 1898. He served in the Seventh Corps, becoming its youngest captain. He was an editor and publisher in Mount Vernon after the war.

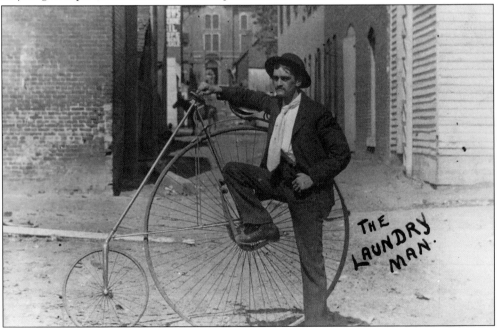

Locally known as the "laundry man," this Mount Vernon character posed with his late-Victorian bicycle near an alley in 1898. In the distance is the 1876 Posey County Courthouse.

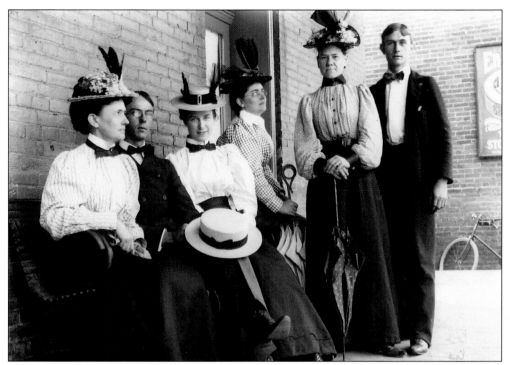

Misses Eloise Mumford, Sallie Law, Maggie Roseman, and Mary Fauntleroy were joined by William Mumford and Homer Fauntleroy on the front porch of the Tavern (formerly Harmonist Dormitory Number 3) in New Harmony, on August 13, 1897.

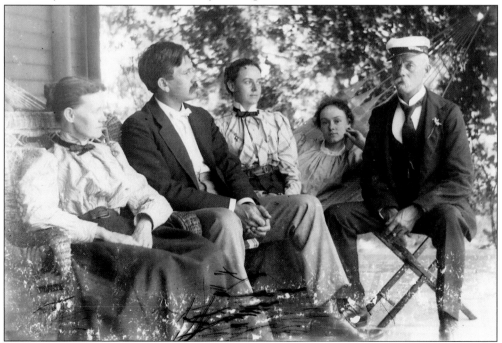

An unidentified group on a front porch in New Harmony, on June 17, 1898, could be typical of any group gathered on a summer afternoon in the Tri-State.

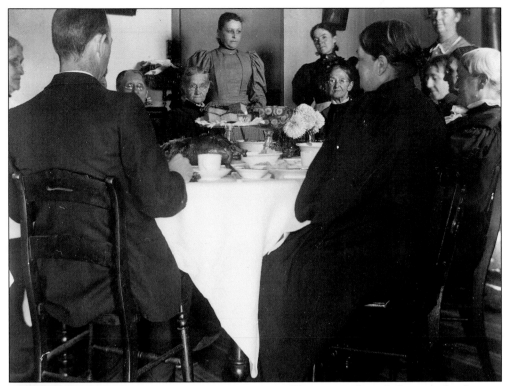

This is an informal photograph of people gathered for dinner in the Fauntleroy Home, New Harmony, c. 1900.

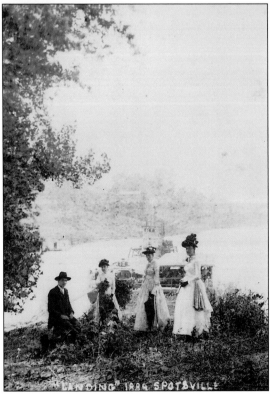

A small group paused to have a photograph taken, possibly on a summer Sunday afternoon, at the Spottsville landing, near Henderson, in 1889.

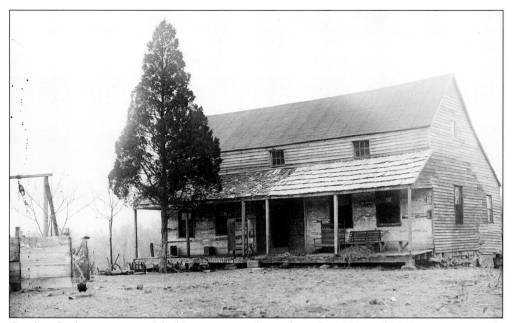

One hundred years ago, modified log structures dating from the 1830s and 1840s were commonly found on the farms surrounding Evansville. The chief additions were a second-story sleeping loft and, below the long, sharply sloping rear roof, a kitchen. In front of this double-log home are its well and its ubiquitous, native red cedar.

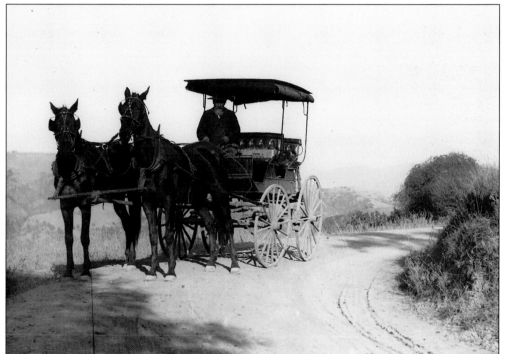

Sights like this were probably common on the rural roads of the Tri-State. This older man, in his buggy with two horses, was possibly a farmer making a special delivery of his produce to a customer.

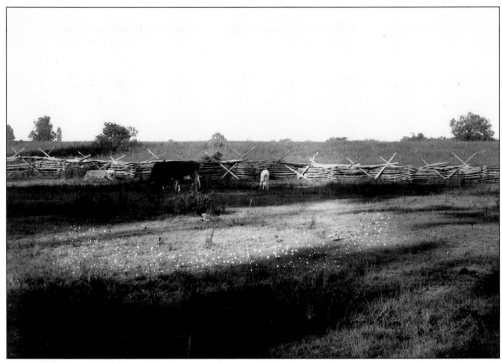

In probably a representative scene in the rural Tri-State, these cows grazed near the split rail fence.

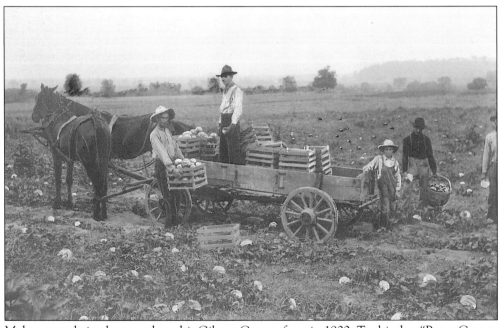

Melons were being harvested on this Gibson County farm in 1900. To this day, "Posey County melons" are a summertime institution.

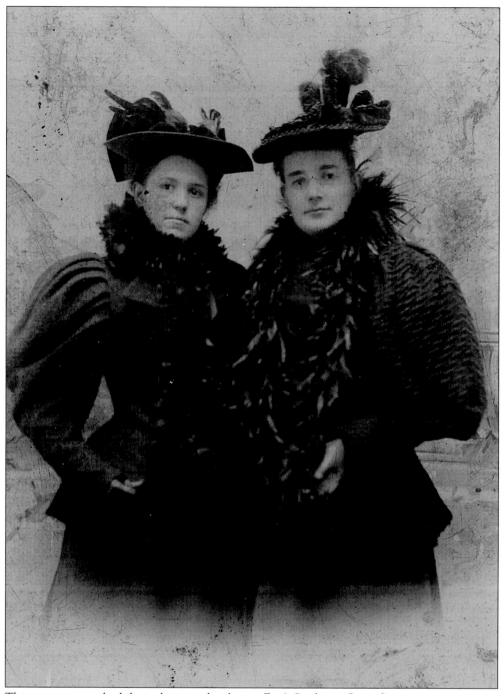

These two women had their photograph taken at Fite's Studio in Owensboro.

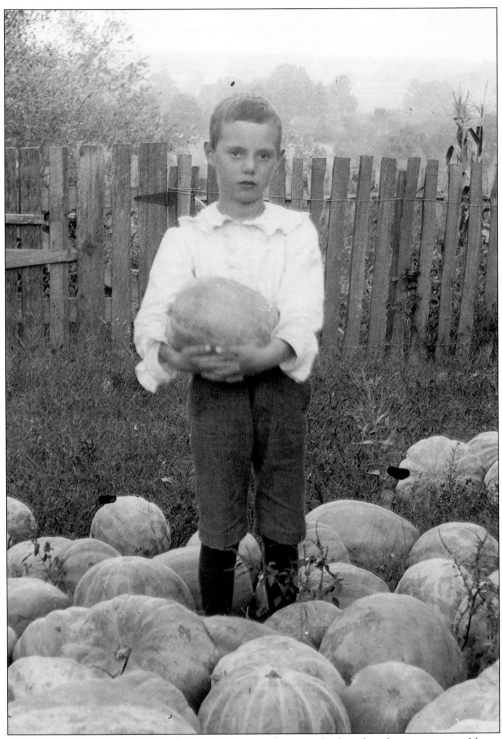

A boy, in his Little Lord Fauntleroy attire, was photographed with a bumper crop of huge melons on an unidentified farm north of Evansville. He somehow captured the innocence of a long-departed era.